MANUEL ANTONIO
BALLENA & CARARA

COSTA RICA REGIONAL GUIDES

Diego Arguedas Ortiz and Luciano Capelli

AN OJALÁ EDICIONES & ZONA TROPICAL PUBLICATION
from
COMSTOCK PUBLISHING ASSOCIATES
an imprint of
CORNELL UNIVERSITY PRESS
ITHACA AND LONDON

First published 2020 by Cornell University Press

Printed in China

Library of Congress Cataloging-in-Publication Data

Names: Arguedas Ortiz, Diego, author. | Capelli, Luciano, author.
Title: Manuel Antonio, Ballena & Carara / Diego Arguedas Ortiz and Luciano Capelli.
Other titles: Manuel Antonio, Ballena and Carara
Description: Ithaca [New York] : Comstock Publishing Associates, an imprint of
Cornell University Press, 2020. | Series: Costa Rica regional guides
| "An Ojalá Ediciones & Zona Tropical publication."
Identifiers: LCCN 2020015082 | ISBN 9781501752841 (paperback)
Subjects: LCSH: National parks and reserves—Costa Rica—Pacific Coast—
Guidebooks. | Natural history—Costa Rica—Pacific Coast—Guidebooks.
| Pacific Coast (Costa Rica)—Guidebooks.
Classification: LCC F1549.P33 A74 2020 | DDC 917.2/8604—dc23
LC record available at https://lccn.loc.gov/2020015082

Front cover photo: Pepe Manzanilla
Back cover photo: Diego Mejías

The world knows Costa Rica as a peaceful and environmentally conscious country that continues to attract several million tourists a year, yet this image may obscure a social and biological legacy that very few visitors get to know.

We hope that the six books in this collection will reveal a reality beyond the apparent one. These are meant to pique the curiosity of travelers through stories about nature, geology, history, and culture, all of which help explain Costa Rica as it exists today.

Each title is dedicated to those who fought, and continue to fight, with grace and wisdom, for a natural world that lies protected, in a state of balance, and accessible to all—in other words, one that is closer to the ideal we seek to make real.

DEDICATION
ÁLVARO UGALDE VÍQUEZ

When he was a mere 20 years of age, biologist Álvaro Ugalde Viquez became intimately familiar with the national parks of Costa Rica as a volunteer. They would become his life's passion. Together with colleague Mario Boza, he would guide the development of the national parks system and, over the course of more than four decades, raise funds for the parks and speak tirelessly with citizens, scientists, and presidents to turn his conservationist dreams into a reality. In large part, Ugalde's pioneering work bequeathed to the country a park system that protects one-fourth of the nation's lands.

In 1970, at 24 years of age, he assumed the directorship of Santa Rosa National Park and subsequently of Poás Volcano National Park. In 1974, he began the first of three tenures as Chief of the National Parks Department (1973–1979, 1983–1985, and 1991–1993), with brief interruptions to continue his studies and fundraise for conservation.

In the early years of the department, when the number of employees could be counted on one hand, his energy and commitment would inspire his colleagues.

On the Pacific coast, Ugalde played a critical role in protecting Manuel Antonio and Corcovado National Parks. In Manuel Antonio, he walked the streets of the town with megaphone in hand to rouse support for the creation of the park. In Corcovado, he was one of the architects of the park, where he would work to reduce the number of gold miners invading it. Few people had the creativity and vision necessary to attract international support, both technical and economic. Ugalde was equally adept at gala dinners in the United States as he was on a trek through the forest of a new protected area. Without his commitment and effort, Costa Rica would not have become the world-famous success story that it is in the history of conservation.

CONTENTS

MANUEL ANTONIO
BALLENA & CARARA

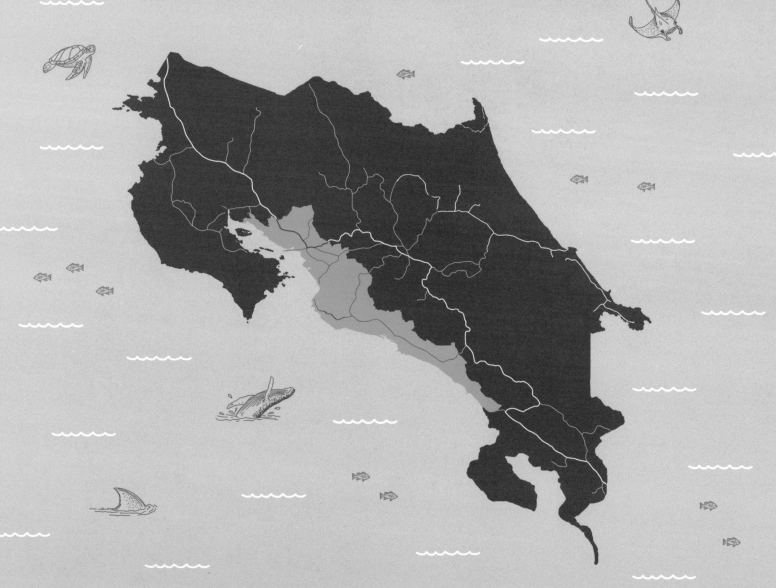

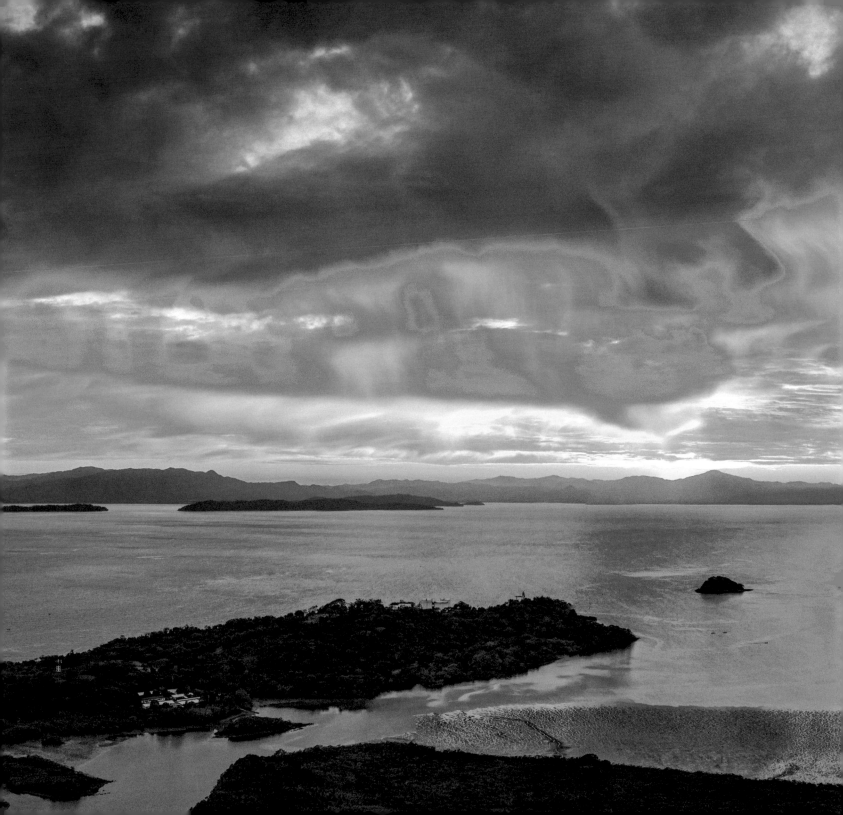

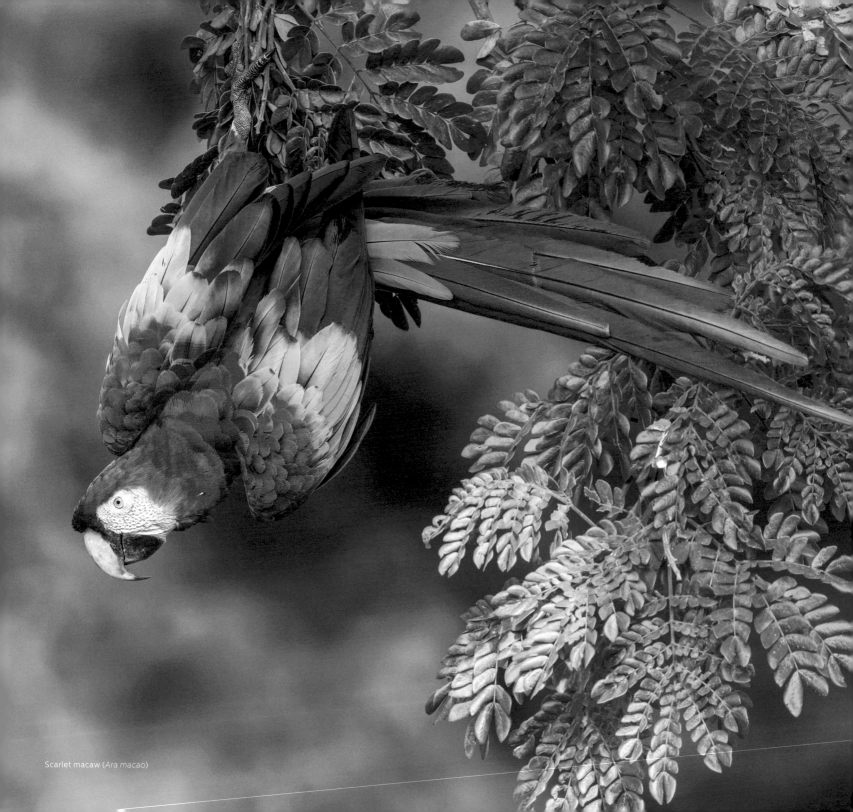

Scarlet macaw (*Ara macao*)

From the concrete bridge above it, the Tárcoles River might at first look like any other river, one of many that tumble down the mountains enclosing the Central Valley, then meander as the coast approaches. Tourists on the bridge, however, are afforded a look at something unusual; leaning on the guardrail, they point at objects along the riverbanks. What are they? A teeming population of American crocodiles (*Crocodylus acutus*), the largest reptile in Costa Rica. The Tárcoles River offers territory and food sufficient for them to thrive, and they, in turn, attract droves of humans, hypnotized by these partially submerged giants. It is a singular spectacle in the country.

But if you lower your camera and don your ecologist's cap, you will learn that this river is not only a haven for the crocodiles. It is the border between two distinct ecosystems whose confluence makes the area invaluable in ecological terms. The dry forest that occurs in the north and the humid jungles of the south meet here, where the flora and fauna of both comingle. This is why Carara National Park, on the south side of the river, is so appealing to visitors. Experts call this protected area, one of the most important in the Central Pacific, a transitional forest, because it contains overlapping ecosystems.

Possessing nearly 13,000 acres (5260 hectares) of protected area, Carara is one of the best places in the country to see birds. With binoculars and field guides in hand, bird watchers arrive from all over the world. Altogether, 459 species of bird have been identified here, about half of those reported for Costa Rica and roughly 5% of all the species in the world. Its popularity among tourists motivated the government to change its status in 1998 from a restricted bio-

logical reserve to a national park, a category that places fewer restrictions on visitors. The first universal access trail for people with disabilities was opened here; it is wheelchair accessible and has signs in braille.

The creation of Carara involved a mix of luck and the willingness to seize opportunity when it presented itself. In 1977, the national government expropriated Hacienda El Coyolar, one of the largest estates in the country, intending to parcel it out to poor landless families. Almost one-third of the estate was covered in forest. The manager of the entity charged with dividing the land questioned the wisdom of giving away this tract of forest and offered it to the nascent National Parks Department. Its director, Álvaro Ugalde, accepted it without hesitation; today, the park is visited by tens of thousands of people every year.

Amid the calls and cries of the diverse wildlife in Carara, a commotion above the canopy focuses one's attention: the culprits are scarlet macaws (*Ara macao*), the most iconic birds to be found here. In the morning, they awake in the mangroves at the mouth of the Tárcoles River and take flight in search of food in the park and nearby areas such as Punta Leona Wildlife Refuge. On their journey, they encounter the fragmented landscape of the Central Pacific and must fly over pastures and agricultural land, where shelter and food are largely absent.

The destruction of habitat and the illegal trade in macaw chicks, which in the 1970s became fashionable in the United States, drastically reduced the number of scarlet macaws in all of Mesoamerica. Although it was a common bird from Mexico to the Amazon, at one point Costa Rica had only two small isolated groups, one in Carara and, farther south, one in Corcovado. Pushed to the point of extinction, the scarlet macaw was on the verge of becoming the dodo bird of the country, but fortunately this wasn't the case.

Today the population of macaws in Costa Rica is growing. In the 1990s, macaws mainly occurred between Tárcoles and Carara, but now they are found from Orotina, in the north, to Playa Hermosa and Bahía Ballena, in the south. According to a recent study, the population of macaws in Carara is around 500 individuals and in Corcovado around 1000. Biologist Christopher Vaughan, who has studied these

birds for decades, attributes their recovery to ecosystem protection and environmental education. While other conservationists breed macaws in captivity to later release them, Vaughan focuses on protecting their natural habitat and the trees they use for nesting, including ceiba (*Ceiba pentandra*), *ajo* (*Caryocar costarricense*), and *galli-nazo* (*Schizolobium parahybum*).

But this region is important not only for its natural history. Before the arrival of Europeans, it was a meeting point for indigenous chiefs from the coast and the valley. During the colonial period and in the first century after independence, the Central Pacific was an area of strategic importance. In 1524, the Spanish conquistadors founded the first European settlement on Costa Rican soil, Villa de Bruselas, a few miles north of modern-day Puntarenas. Expeditionary forces to the interior of the country set out from these hot, coastal plains, following along the valley carved out by the Tárcoles River, and conquered the Central Valley.

In the 19th century, when coffee became the first Costa Rican export product, practically all bushels of the so-called *grano de oro* (golden bean) were shipped out from the port of Puntarenas. This would continue until the end of the century; with the construction of the railroad between San José and Limón in 1890, Puntarenas lost its importance as a shipping port, though it would be reborn as a popular vacation spot. Indeed, Puntarenas turned into *the* destination for beach goers and would continue to be the main tourist destination in the country for most of the 20th century.

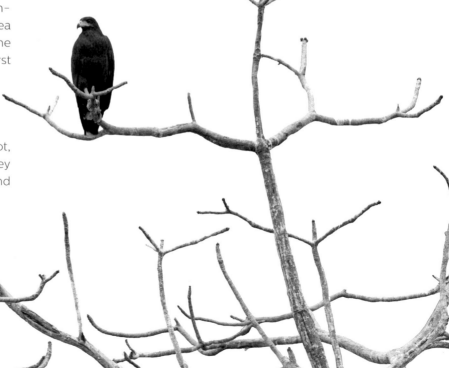

The arrival of the railroad to the Pacific in 1909 made it accessible to yet greater numbers. Attracted by the promise of a season at the beach, wealthy families from the interior of the country built vacation homes on the tongue-like peninsula of Puntarenas, while poorer families took day trips or found cheap accommodations. By 1940, it was the most prominent tourist destination in Costa Rica, and its streetlights illuminated the surrounding areas.

This period of glory lasted only a few decades. Better routes to other parts of the country, the decision to move the port to Caldera in 1981, and the deterioration of the city diminished its popularity toward the end of last century. But people still visit the region. From the pier in Puntarenas, boats head out to see dolphins or explore the islands in the gulf, and, farther south, lies Jacó, a town dedicated to partying and surfing.

Small boats move through the mangroves in Guacalillo, carrying tourists in search of falcons, osprey, little blue herons, and howler monkeys. This mangrove forest, a cradle of life, sits at the mouth of the Tárcoles, the most polluted river in Central America. With a little more than 900 acres (365 hect-

ares) of mangrove, it contains black mangrove (*Avicennia germinans*), red mangrove (*Rhizophora mangle*), white mangrove (*Laguncularia racemosa*), and tea mangrove (*Pelliciera rhizophorae*), four of the five species that grow in Costa Rica.

If the persistence of the mangrove is surprising given its proximity to the unclean flow of the river, equally extraordinary is the presence, just a few miles upstream, of the crocodiles that still play in the polluted water below the bridge from which tourists observe them. Biologists have yet to understand how these reptiles survive given the water pollution, but they know that their population is growing. With good luck, they will return to their historic numbers. In the Huetar language, that of the original settlers of this and other regions of Costa Rica, Carara means "river of crocodiles," a testimony to their historical presence. If the macaws rule the skies, these reptiles are the most popular river species of the Costa Rican Pacific.

Between September and October, crocodile breeding season begins, and the strongest males move weaker competitors out of their territory, forcing them from their natural habitats, sometimes

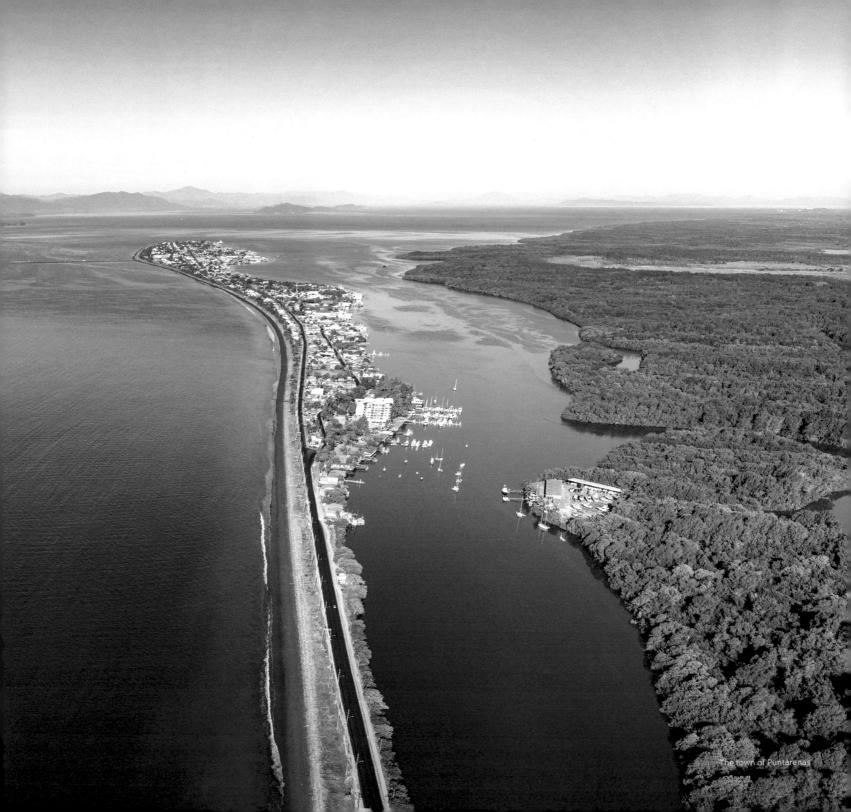

The town of Puntarenas

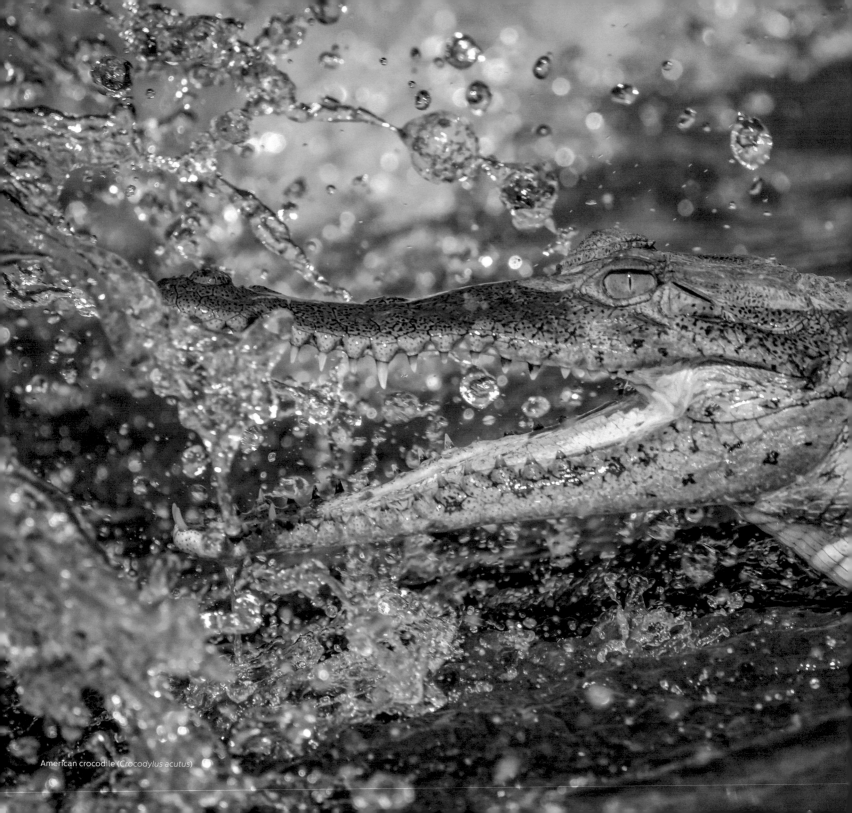

American crocodile (*Crocodylus acutus*)

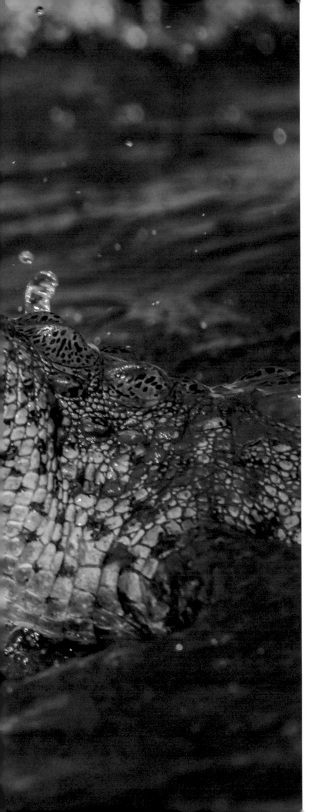

to spots near homes in the area. After nesting at the beginning of the year, the eggs in each nest hatch and the babies start their life on the riverbanks on which they were born. Tourist guides watch from a safe distance, as do the tourists willing to pay the money to see the hatchlings.

Somehow, life continues on this coastal strip between the mouth of the Tempisque River, in the north, and Punta Judas, on the south end of Playa Hermosa. Macaws survive, even thrive, despite the fragmented patches of forest; the mangroves grow in the middle of the polluted water; and tourism persists despite economic highs and lows. Visitors remain squinting on the bridge, looking for crocs. Life flows. And, in the midst of everything, so does the ancient Tárcoles River, tracing a border between the dry forests in the north and the jungles in the south.

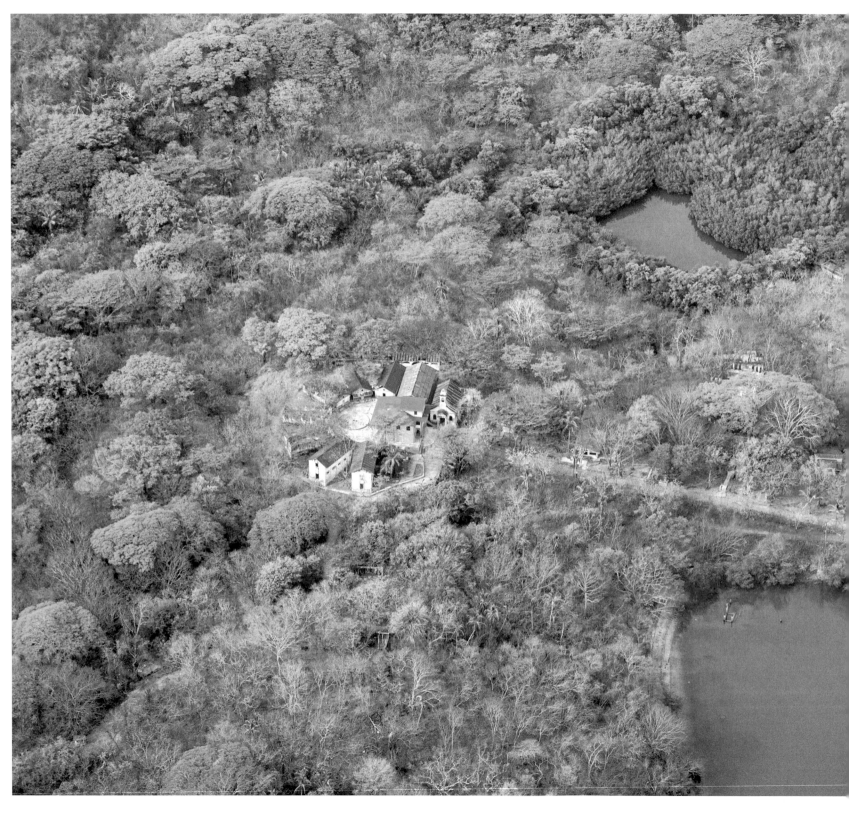

ISLAND
PRISON

Only 5 miles (8 km) east of Puntarenas, San Lucas Island served as a penitentiary for more than a century—it was closed in 1991. Since then, nature has reclaimed the island, transforming it into a place worthy of being declared a National Wildlife Refuge in 2001.

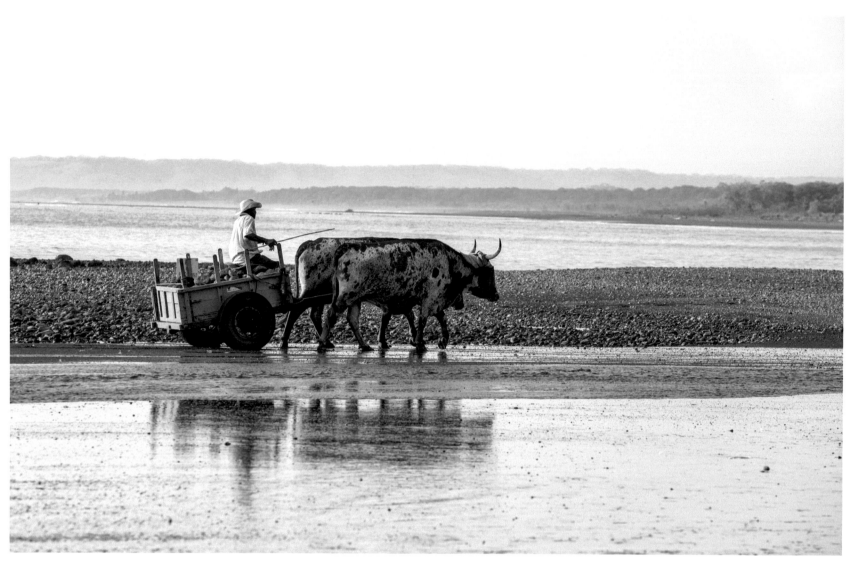

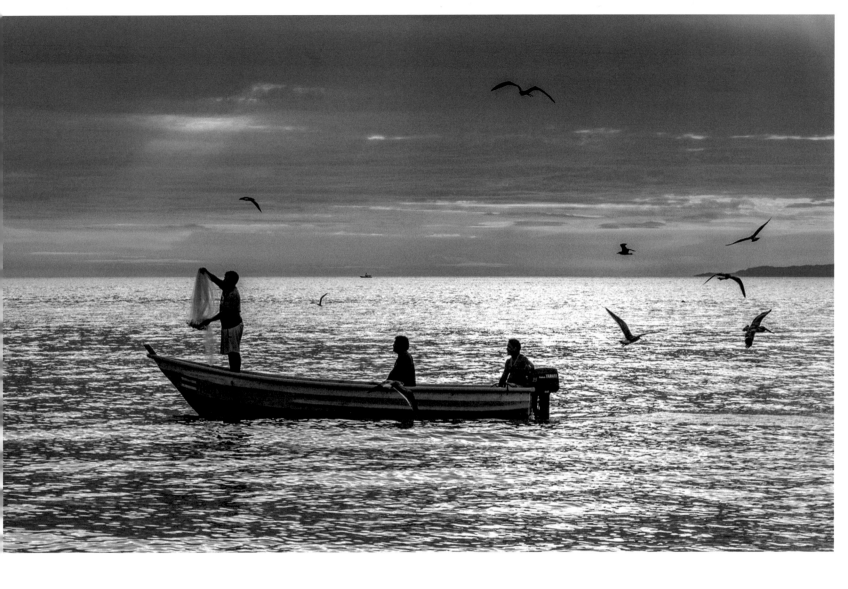

Ocean saltwater meets the currents of the Tempisque River in the Gulf of Nicoya and this exchange makes the gulf an ideal breeding place for dozens of fish species. Despite the drastic reduction in fish populations, most people who live in the Central Pacific still make their living from the sea.

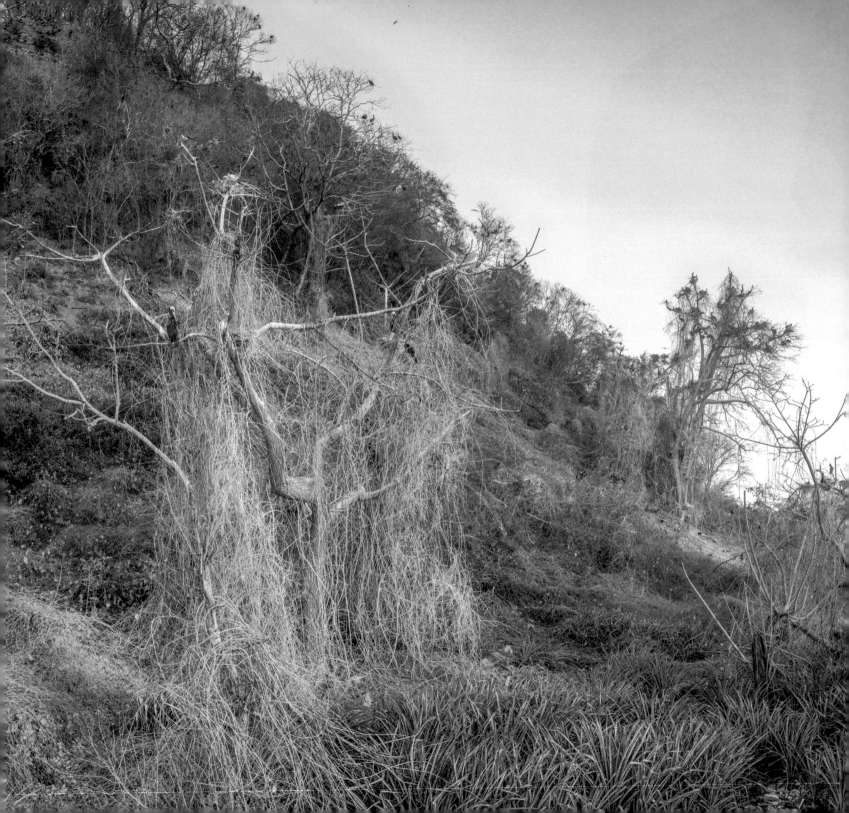

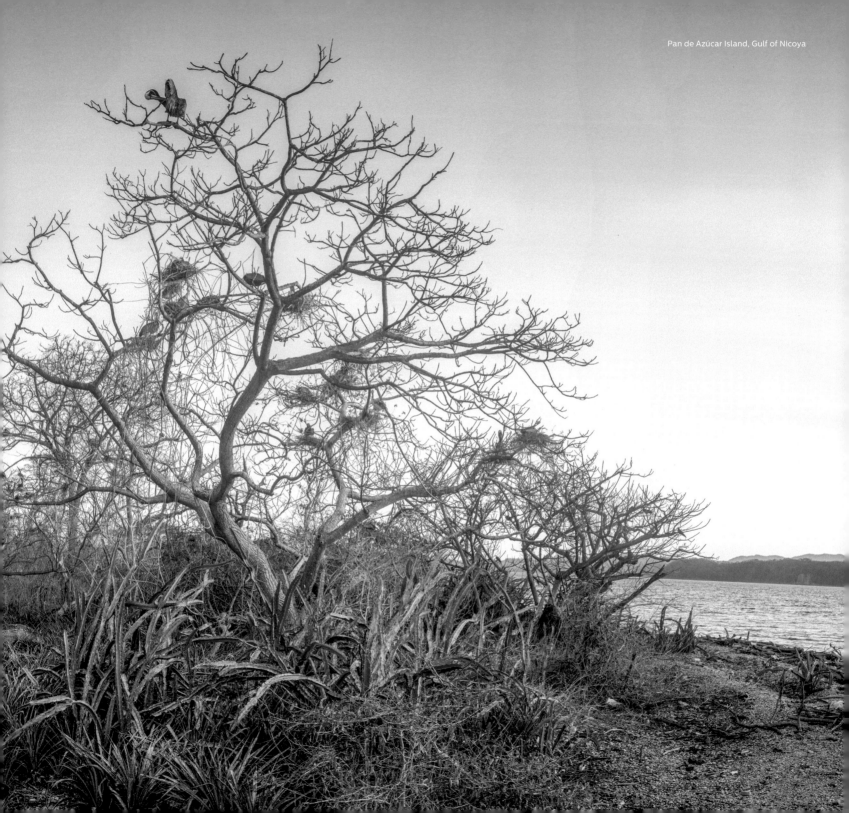

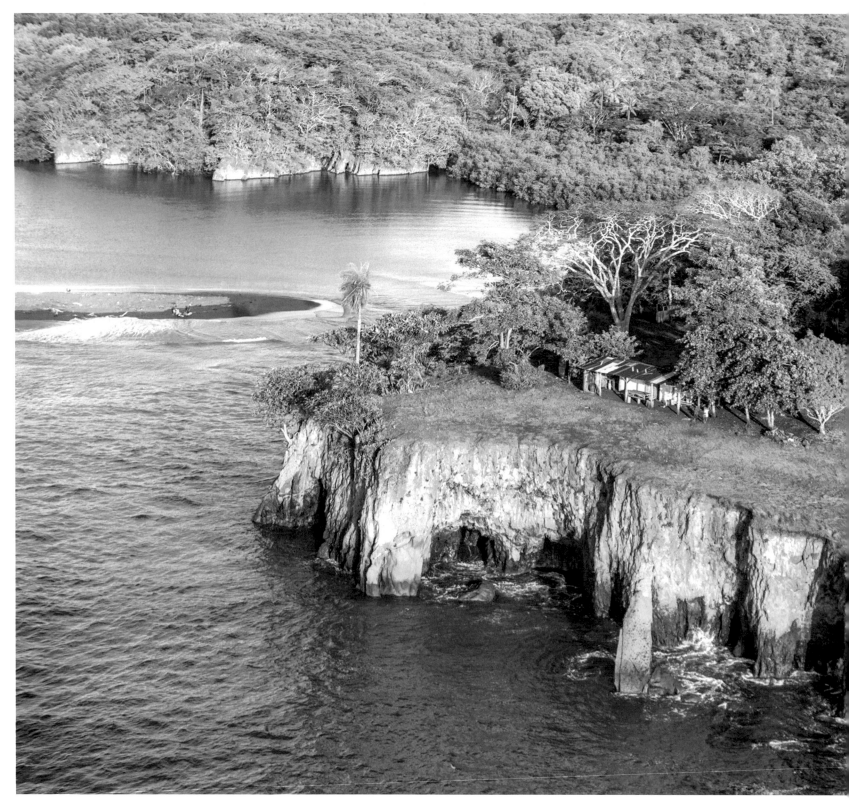

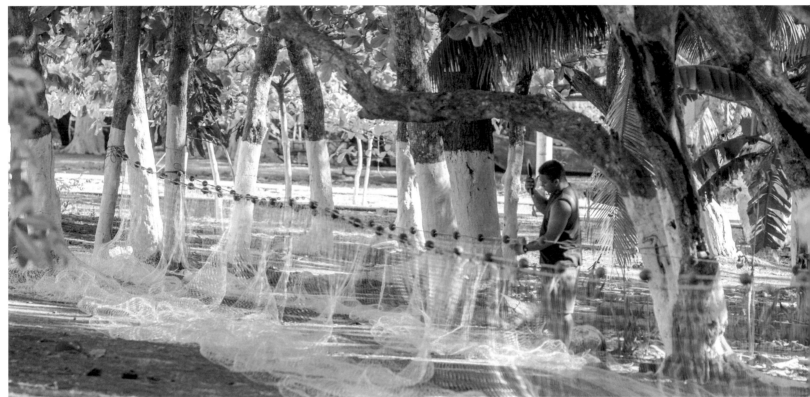

With the arrival of the train and the first cars carrying ice, at the beginning of the 20th century, the flourishing fishing industry began exporting to the Central Valley. After decades of exploiting once abundant stocks, commercial fishermen would end up leaving the Gulf of Nicoya in the 1980s, opening a space for artisanal fishermen, who today still cast their nets and hooks.

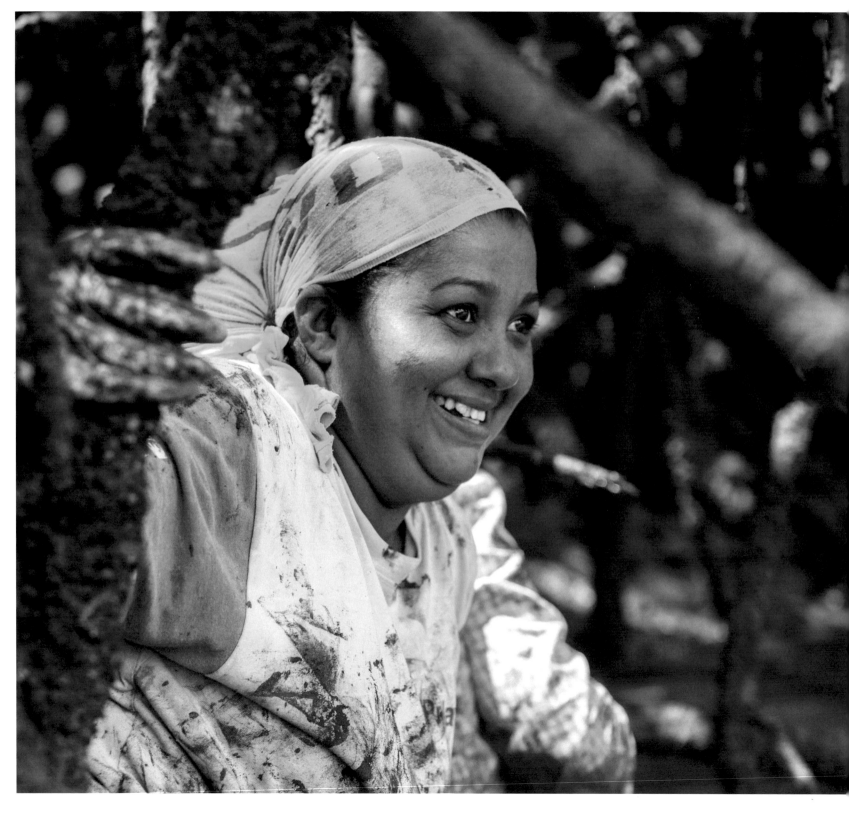

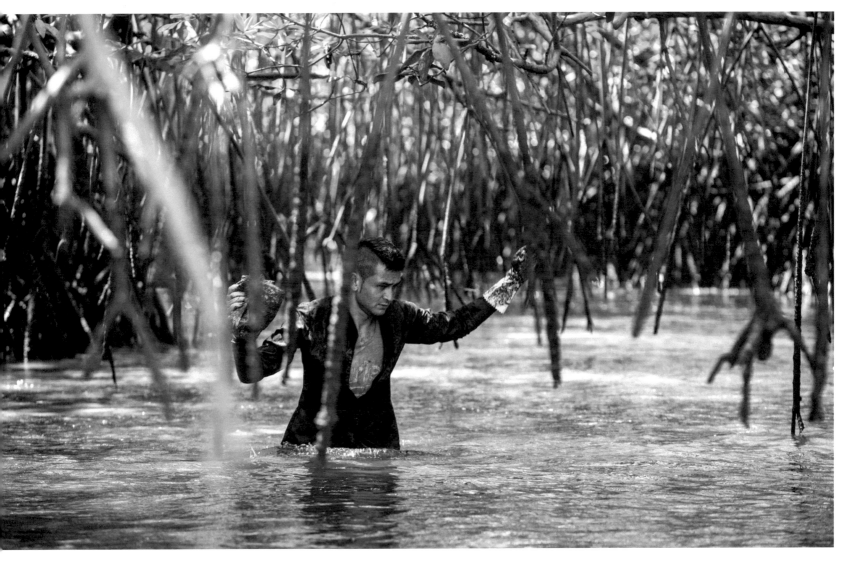

When the tide is low and the ground left exposed, shellfish harvesters roam the mangroves, searching for a hard, black shell, known variously as *pianguas*, *chuchecas*, or mangrove cockles, valued for making ceviche. Day by day, their search becomes harder, as poverty and the lack of employment opportunities in the area have led to an overexploitation of this resource.

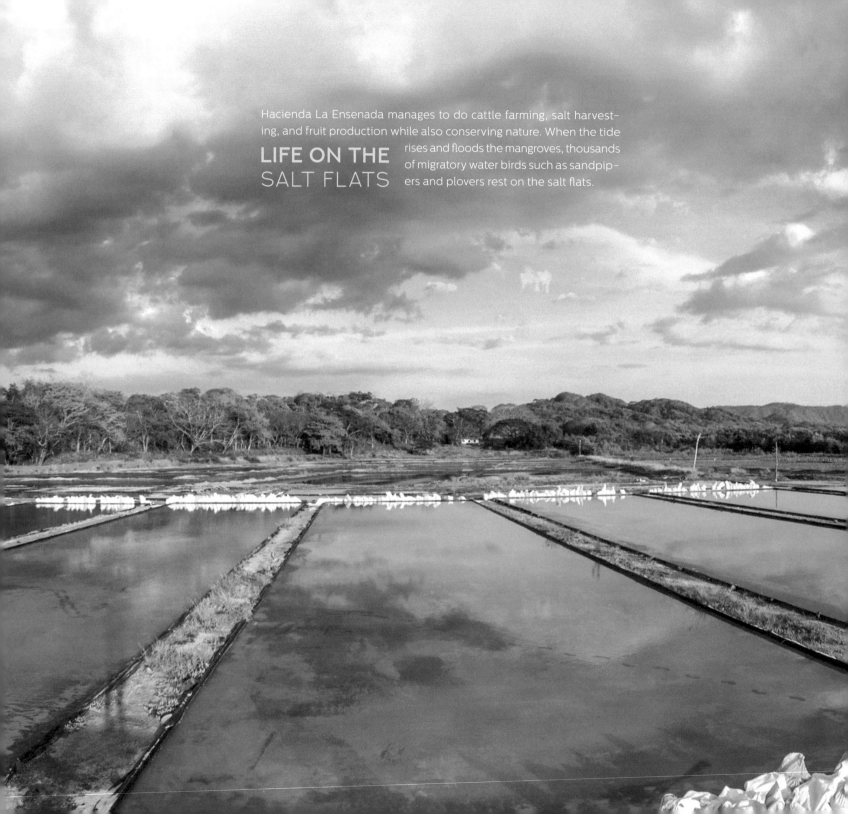

LIFE ON THE
SALT FLATS

Hacienda La Ensenada manages to do cattle farming, salt harvesting, and fruit production while also conserving nature. When the tide rises and floods the mangroves, thousands of migratory water birds such as sandpipers and plovers rest on the salt flats.

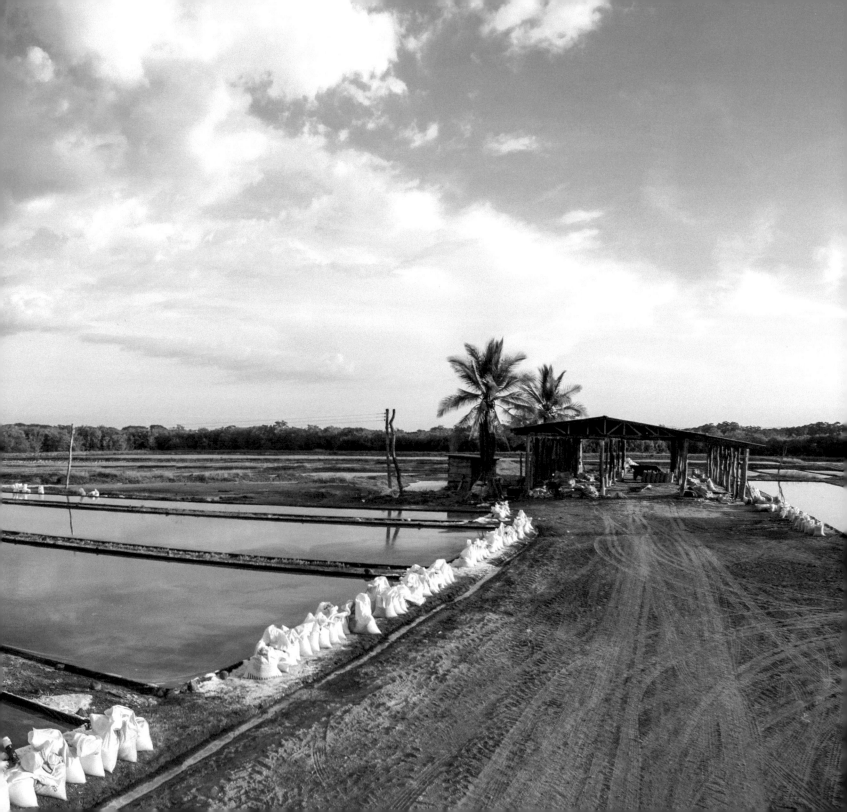

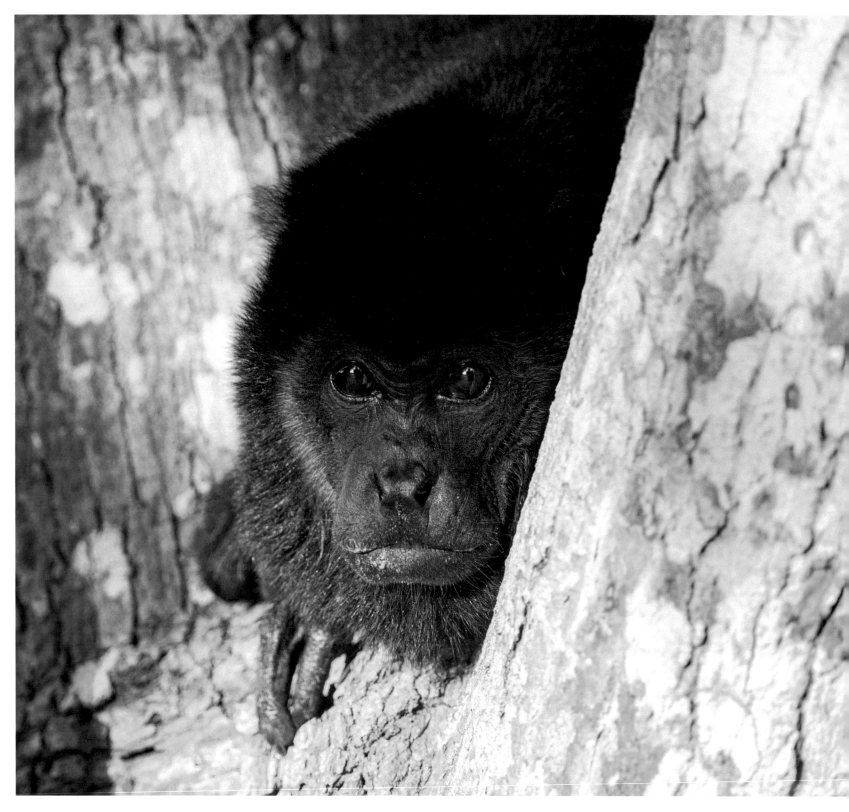

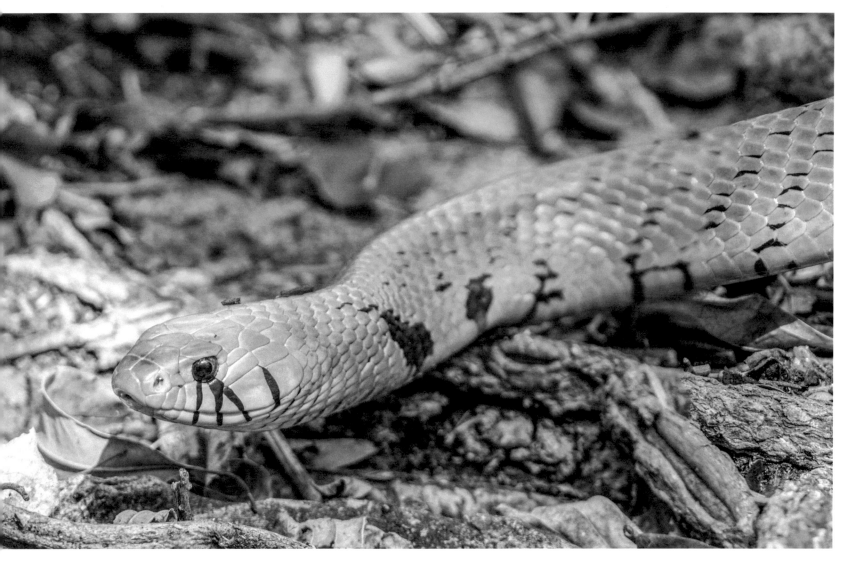

In transitional forests, life is at once loud and discreet. In the canopy, the howler monkey (*Alouatta palliata*) creates a scandal, using its menacing howls—out of all proportion to its tiny body—to drive off males that invade its territory. Sixty feet below, a black-tailed cribo snake (*Drymarchon melanurus*) slithers silently through the leaf litter on the ground, looking for prey.

All living things leave a trace, whether trails through the jungle, tracks in the mud, or scratch marks on trees. The signature of *Homo sapiens* is often more durable and systematic, as seen on this field about to be planted with pineapple.

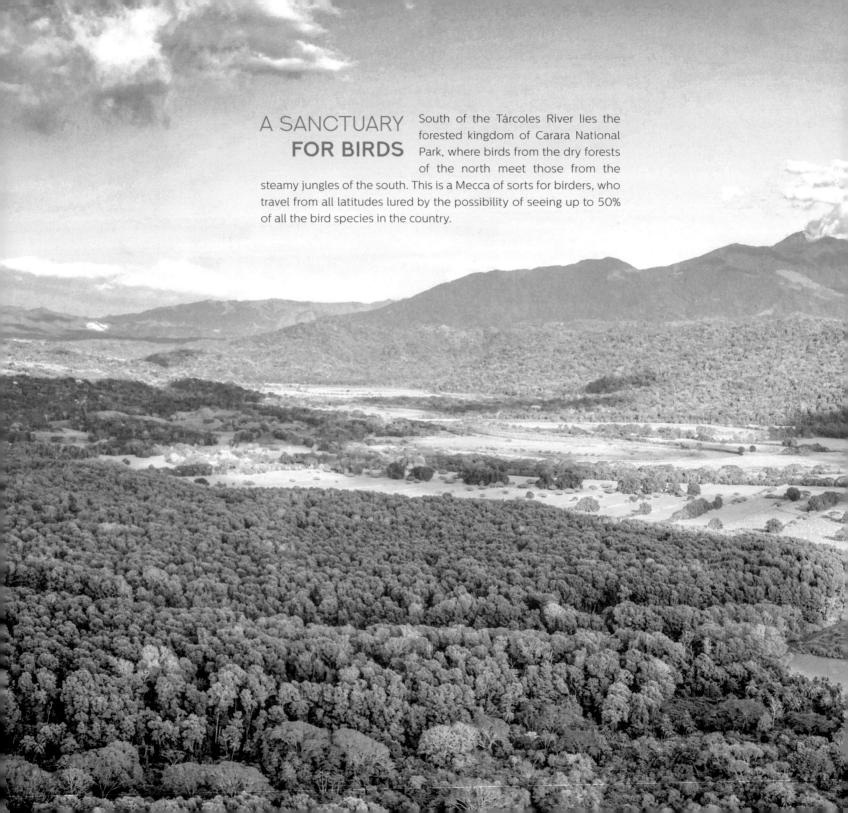

A SANCTUARY
FOR BIRDS

South of the Tárcoles River lies the forested kingdom of Carara National Park, where birds from the dry forests of the north meet those from the steamy jungles of the south. This is a Mecca of sorts for birders, who travel from all latitudes lured by the possibility of seeing up to 50% of all the bird species in the country.

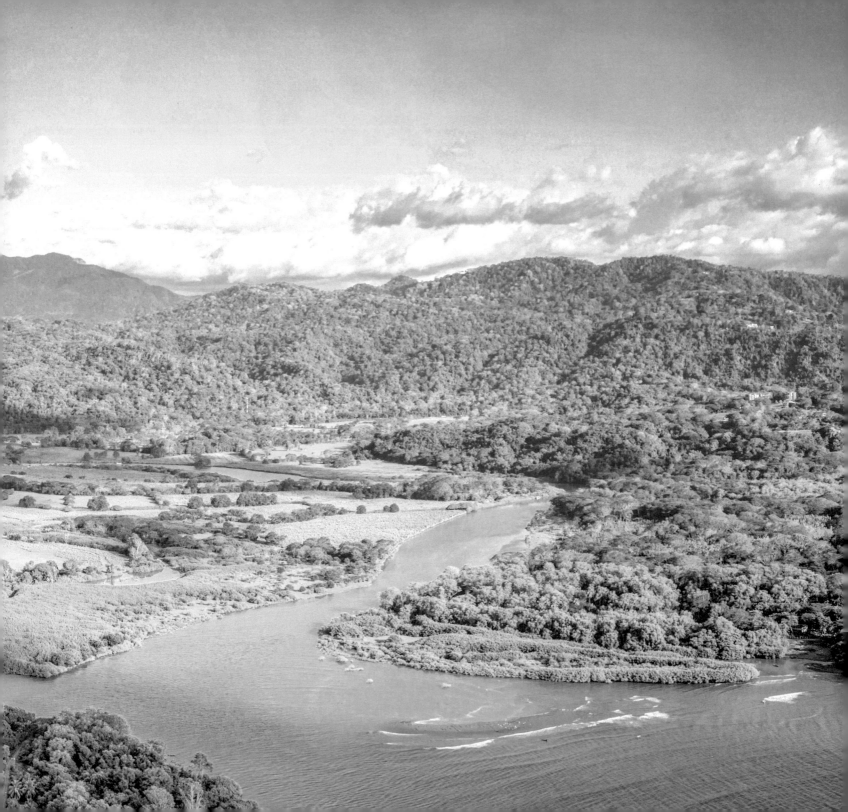

AN ORANGE
ACROBAT

Orange-collared manakin (*Manacus aurantiacus*) males have a complex courtship ritual: they clean the litter from a small circular area of the forest floor, above which they hop from branch to branch, just a few inches off the ground. With each hop, they make a snapping sound with their wings; this sound has earned them their Spanish nickname, *quiebrapalos* (twig breakers). If the male is suitably impressive and the female accepts him, they hop together before mating within the cleared area.

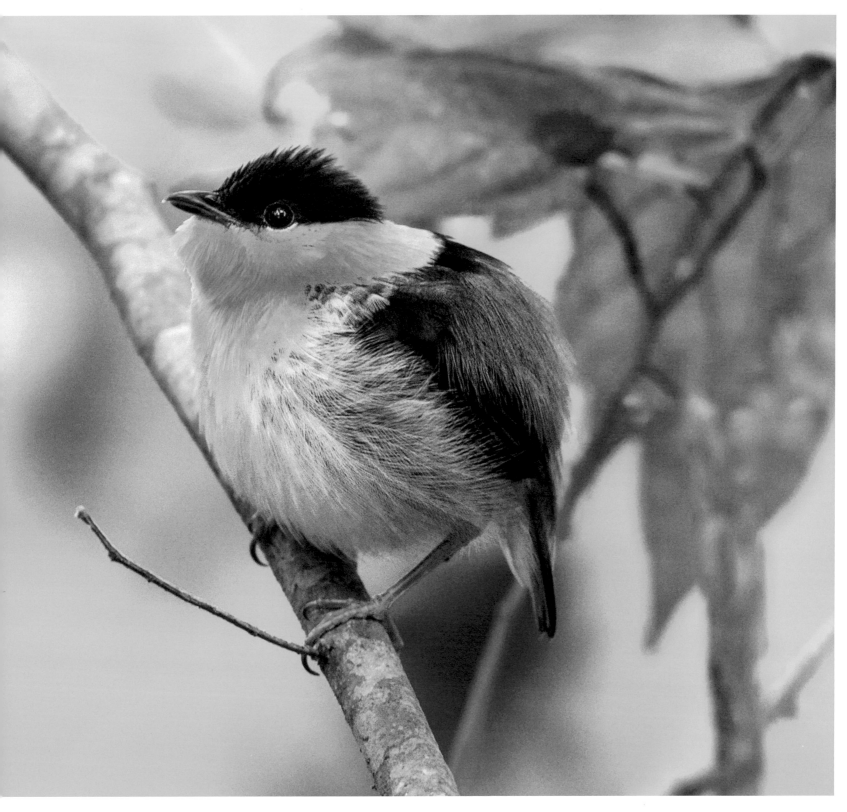

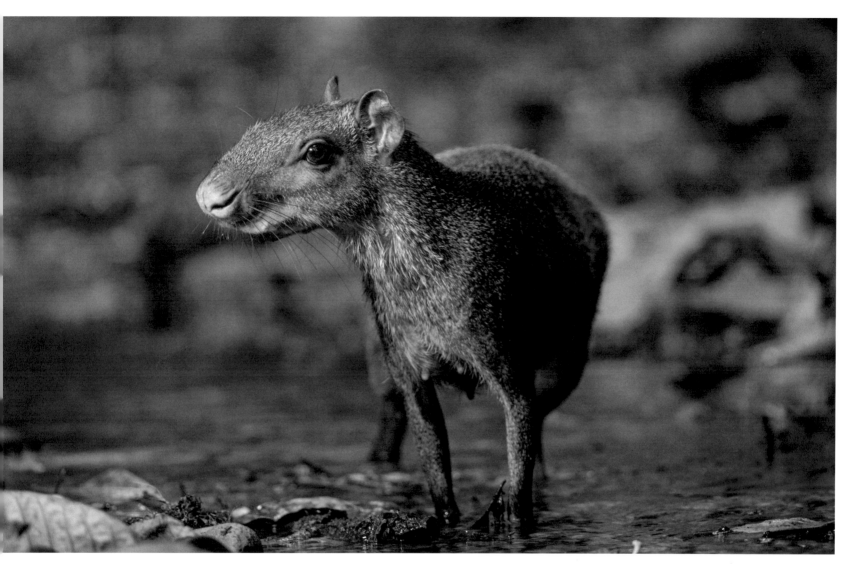

In Carara National Park, the Quebrada Bonita trail offers a favorite birding spot. In the late afternoon, a small stream known as "the manakin bath" lures in species sought by birdwatchers, among them the red-capped manakin (*Ceratopipra mentalis*), blue-crowned manakin, and orange-collared manakin. The flow of the stream even attracts small mammals such as this agouti (*Dasyprocta punctata*).

SCARLET SPECTACLE

Scarlet macaws (*Ara macao*) are social animals that fly in flocks above Carara, Tárcoles, and Punta Leona in search of food. These birds eat the seeds and fruits of 43 species of plants of the Central Pacific, including both old favorites, such as the beach almond (*Terminalia catappa*), and new additions to their diet (which arrived later with monoculture crops) such as African palm, gmelina, and teak.

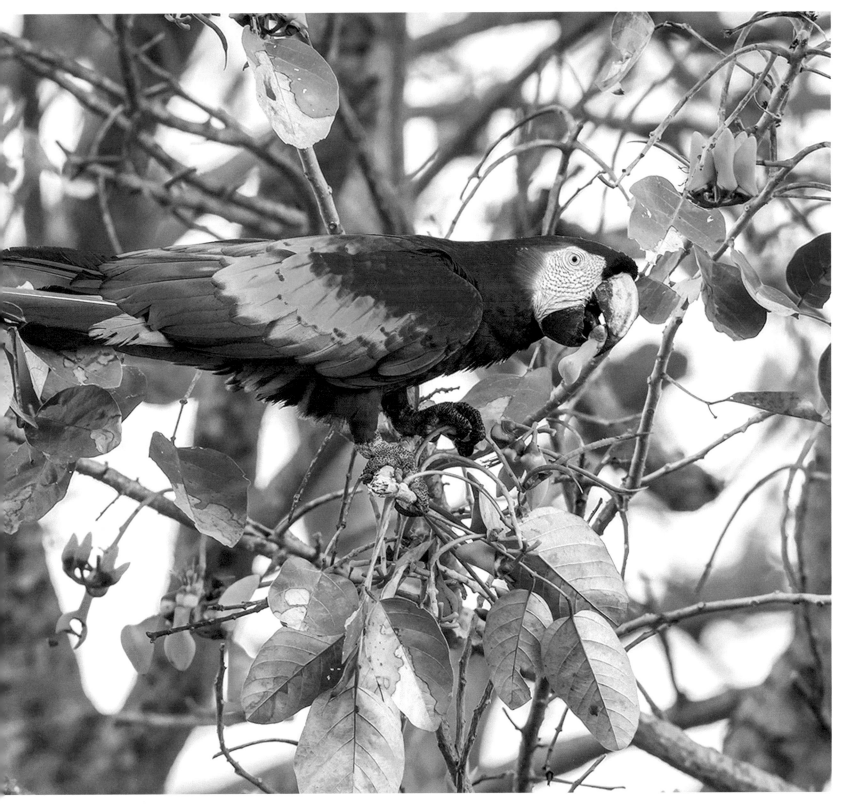

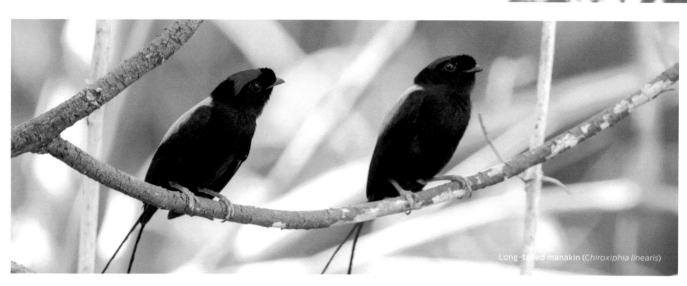
Long-tailed manakin (*Chiroxiphia linearis*)

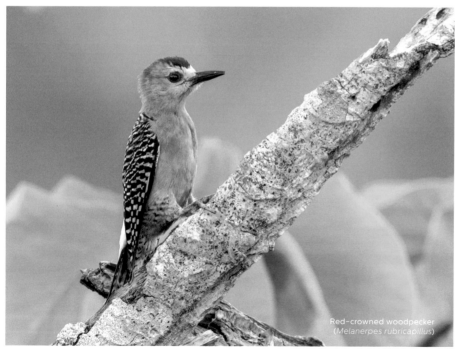
Red-crowned woodpecker
(*Melanerpes rubricapillus*)

Barn owl (*Tyto alba*)

In a single day, it is possible to see more than 100 species of bird
in the transitional forests of Carara.

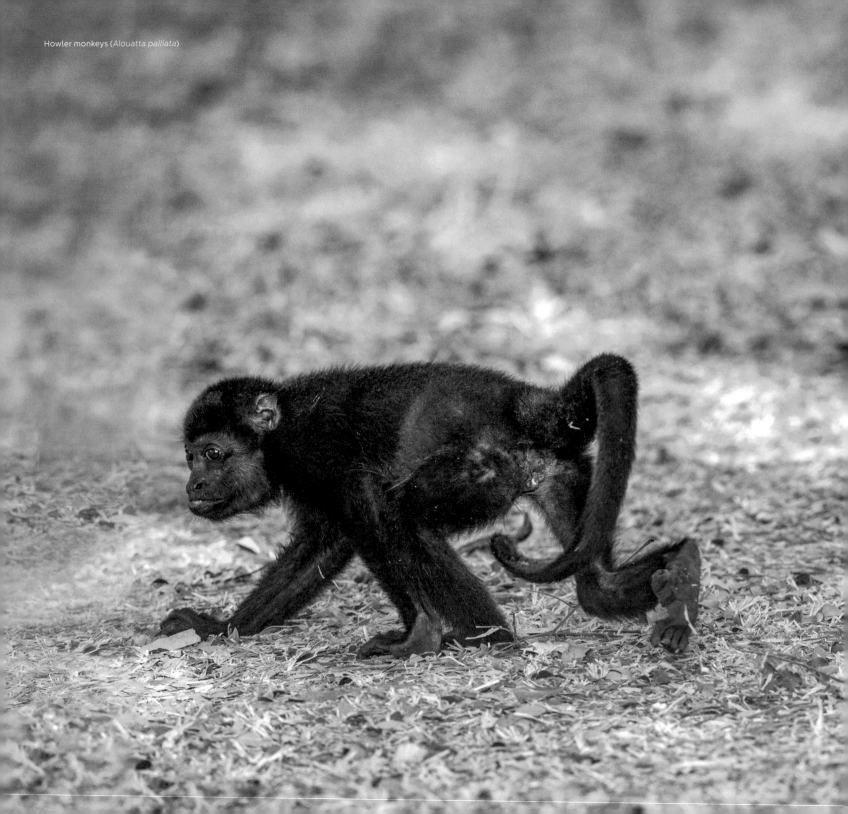

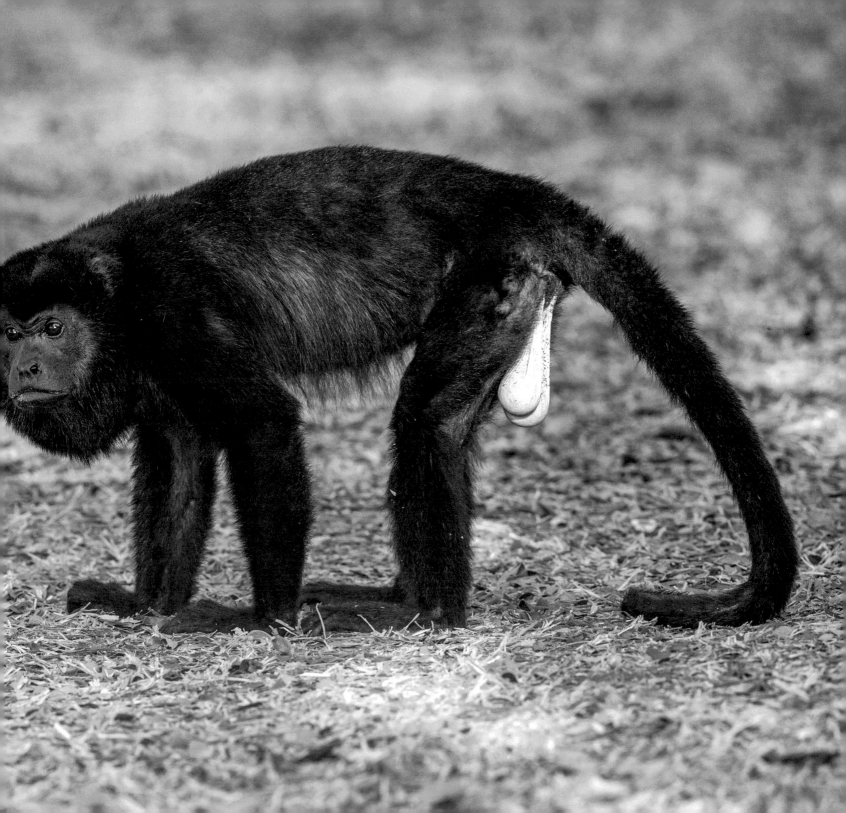

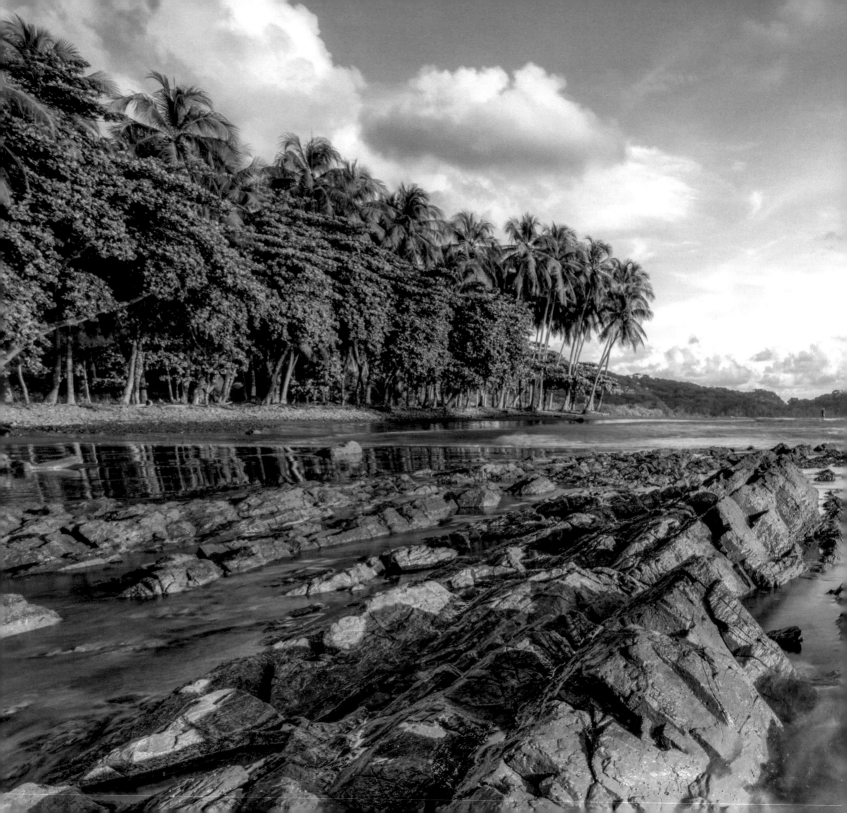

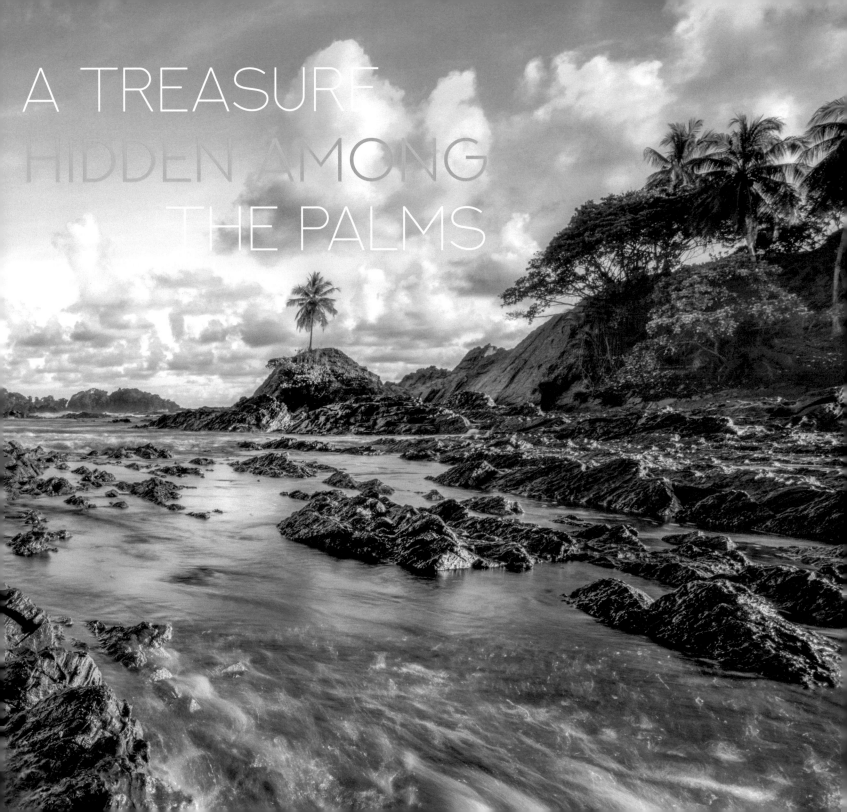

A TREASURE
HIDDEN AMONG
THE PALMS

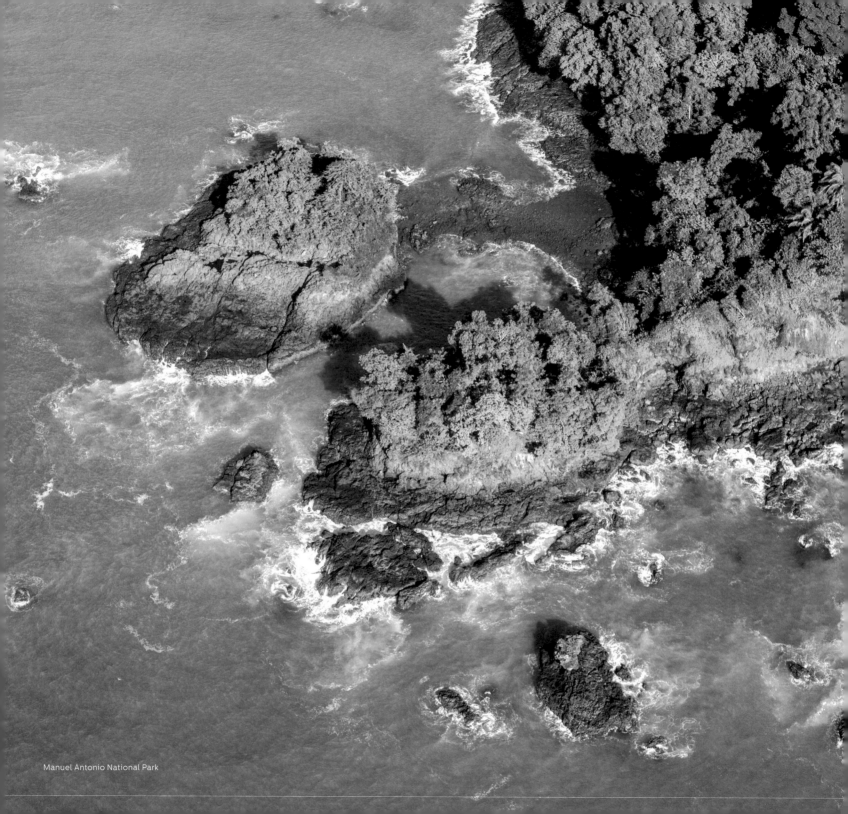

Manuel Antonio National Park

As you climb up, the mountain begins to reveal itself. On your left, you pass a wooden hotel that seems to have been built a century ago, on your right, signs announcing surf lessons and, farther along, the entrance to an LGBTQ beach retreat. Higher up, as you reach the summit, the glimmer of the sea appears below you. You see it in the distance, beckoning from beyond the treetops, the glint of the sun on the waves indicating Manuel Antonio National Park, cloistered on the other side of the mountain.

This steep and narrow road is the only route to your destination, but the reward is great: you are greeted by Playa Espadilla, with gentle lazy waves and men selling coconut water. A little way ahead is the national park, teeming with life.

Manuel Antonio collects in one spot everything for which this country is famous: beaches, biodiversity, and ecotourism. Here, distilled, is the green Costa Rica presented in travel magazines: white-faced capuchin monkeys (*Cebus capucinus*) posing for pictures, an everchanging coastal forest, and tanned tourist guides carrying bird books. There are sandy beaches, a small mangrove forest, a handful of islands off the coast … all in a compact, dense environment. While it is the smallest national park, more people visit it each year than any other. Despite the crowds, the jungle tends to mute the noise made by visitors—at Puerto Escondido lookout, the only sounds are those of the waves breaking against the cliffs of the bay.

In the morning, the first tourists tune into the silence and tiptoe along the path to the visitors' center. They are alert, looking toward the treetops. Every dozen steps or so, their guide pauses and sets down the telescope tripod she carries on her shoulder. What is on view through the lens? Perhaps a three-toed sloth (*Bradypus variegatus*), perhaps an osprey (*Pandion haliaetus*). Over 100 species of mammal, 184 species of bird, and 350 plant species have been recorded in this small paradise. If the tourists are lucky, they will see the Central American squirrel monkey (*Saimiri oerstedii citrinellus*), a subspecies endemic to a tiny region of the country that finds refuge in Manuel Antonio in the face of habitat loss. But for many, the scenic beauty of the park suffices, whether one sunbathes on the white sand beaches or walks the trail that encircles Cathedral Point, with its three viewpoints overlooking the sea.

All of this takes place on fewer than 8 square miles (20.7 km²) of protected land. Beyond its borders, the landscape becomes unrecognizable. About 4 miles (6.4 km) north, on the other side of the mountain, is the noisy port of Quepos and, beyond that, the rattling of trucks carrying African oil palm fruits. This is the agricultural heart of the Central Pacific. Depending on your bent for metaphor, Manuel Antonio can be described as an oasis amid the plantations or an animal imprisoned between the coast and the monocultural fields of Parrita and Quepos. Beyond the park, the wildlife finds little respite from the effects of "development."

The responsibility for the environmental degradation rests in part with the United Fruit Company. This corporation first brought banana production to the region, in 1934, after abandoning the Caribbean coast of Costa Rica; years later, it would also plant African oil palm. In a steady stream, foreign businessmen descended from small airplanes to colonize these lands, in a sense repeating the tactics of Juan Vásquez de Coronado and other 16th century Spanish colonizers who stripped the Quepo indigenous peoples of their land. From the first years of the Spanish occupation to the moment United Fruit arrived, little occurred here, but the tumultuous, strife-filled years that followed would make each decade seem like a century.

The forested plains began to give way to expansive farms and small agricultural workers' villages. The "Yunai," a popular adaptation of the name United, influenced the coastal life of the Parrita and Quepos cantons in true banana republic style, playing the role of both employer and government. It installed the first plumbing and electrical systems in Parrita, built the first hospital and power plant in Quepos, and attracted thousands of people from Guanacaste, the Costa Rican Central Valley, and Nicaragua. Local and national authorities danced to the beat of the United Fruit Company, always pliant, always complacent.

Banana production began to decline in the 1950s, plagued in part by Panama disease, which is caused by a fungus.

The African oil palm would replace it. Quepos was the first spot in Costa Rica where the United Fruit Company began planting it commercially, in 1943, and the fields grew in number in the following years. Although the old banana towns switched crops, they looked pretty much just the same as always: ramshackle homes raised on stilts, placed around a soccer field, and decaying headquarters, all surrounded by the plantations, just a stone's throw from the kitchens in the workers' homes. United Fruit left the area in the 1980s but forgot to take the oil palms with it.

Just as the banana company had managed to achieve monopoly control over the crops, other foreigners tried to take

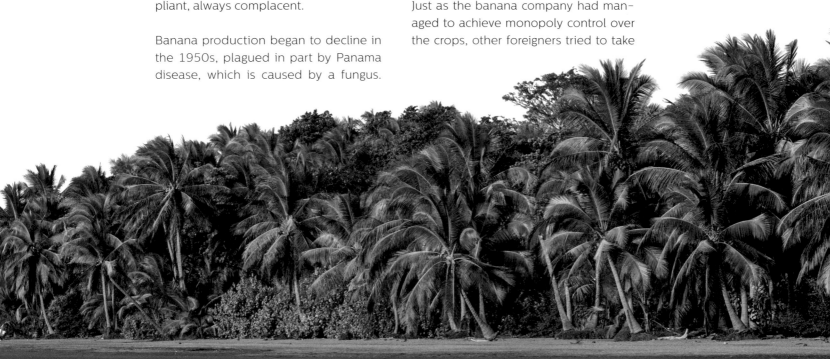

possession of the beaches. It all began with a gate. The three Manuel Antonio beaches—Espadilla, just outside the park, and Espadilla Sur and Manuel Antonio, both within the park boundaries—had been a recreation area for the people of Quepos and the surrounding areas for years. When a Frenchman put up barriers in 1971, with the justification that it was his property, it caused a stir; while the land may have been his, the barriers blocked access to the beach, which was not. A farmer and his workers knocked down one gate; a young man borrowed a jeep from his parents to rip away another; and a third was brought down with the help of a tractor. Some would argue, therefore, that the national park at Manuel Antonio owes its creation less to the conservationist movement of the 1970s than to a group of kids who wanted to get into the water.

The Frenchman continued to put up gates until February of 1972, when pupils from the high school in Quepos arrived at night with mallets, pickaxes, and wrecking bars to knock down a gate and the pillars that held it. They then took the mallets to the house that the European was building. When he called the police, the locals played their trump card; they contacted the emerging National Parks Department, led by Álvaro Ugalde, and urged the department to take these beaches under its wing. Ugalde saw an opportunity and walked the streets of Quepos with a megaphone, encouraging the population to reclaim their lands. A local legislator took this crusade on and introduced a bill to create the protected area.

By November of 1972, Manuel Antonio National Park had become a reality. Its official designation as a protected area created a shift in the region. While the rest of the Central Pacific continued on its unbridled track toward monoculture, Manuel Antonio became a beacon for tourism. Here, a different life was created.

Despite this, the oil palm plantations grow closer to the park each year. A Stanford University study of land within a roughly 20-mile (32-km) radius from the park, revealed that oil palm plantations increased from 8% of land use in 1985 to 14% in 2008. Seen in

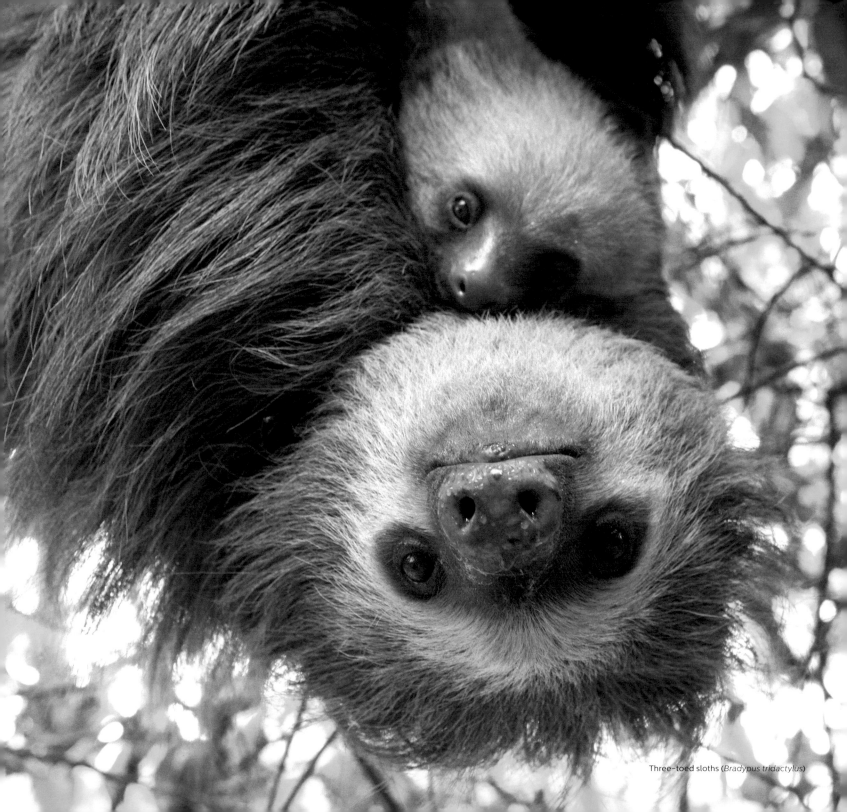

Three-toed sloths (*Bradypus tridactylus*)

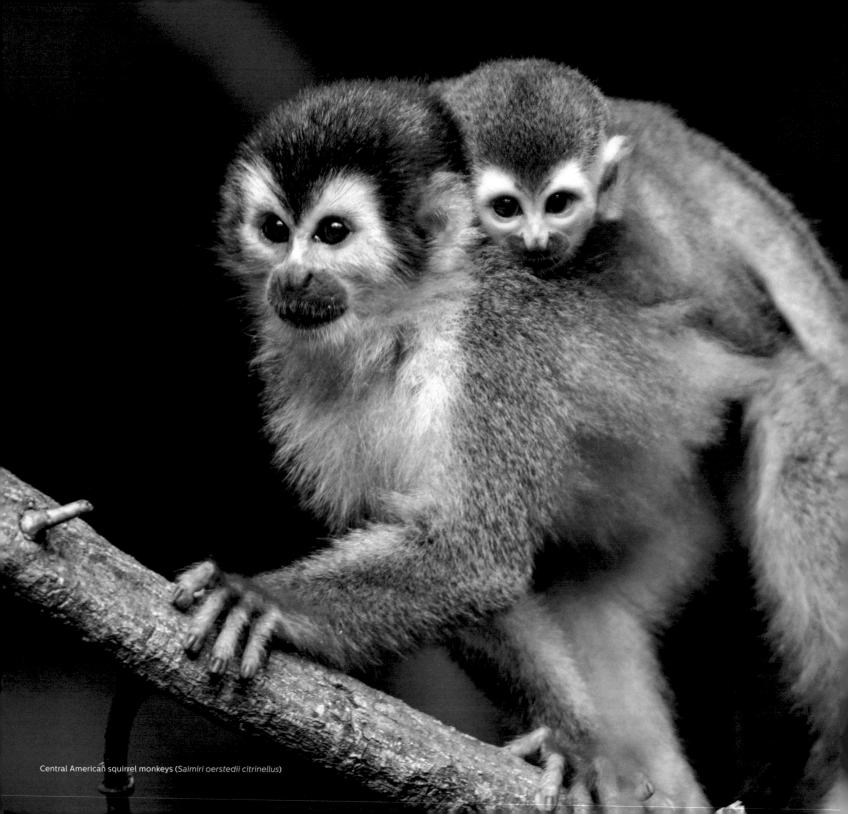

Central American squirrel monkeys (*Saimiri oerstedii citrinellus*)

satellite imagery or from an airplane, the crops around the park resemble a claw closing in on the jungle, strangling the few biological corridors that still connect the coast with the Dota and Tarrazú mountains.

Yet somehow Manuel Antonio still harbors life and attracts tourists. So many that the park had to install a new gate, where tourists gather every morning. When it opens, the park guards start counting: one hundred, two hundred, three hundred … and so on until they reach the maximum number of people allowed per day, which is almost always lower than the number of people in line.

For the local community, the gate is a reminder that the tourism that feeds them comes at a price. In the morning bustle outside of the park, guides walk with their telescopes, coconut water vendors make their first sales, and tourists in shorts wait for the gate to open and give them access to this quiet forest temple, as waves rock back and forth nearby. This green natural treasure no longer holds space for the children of Quepos—they will bathe at another beach.

Between 15 and 10 million years ago, sediment was deposited on what is today called Punta Judas or Punta Mala. Later, these rocks were "tilted" by tectonic processes, leaving the strata layered one on top of the other, creating rocky

HISTORY INSCRIBED
IN STONE

platforms that extend half a mile into the sea, like highways, at low tide. Are these landing spots for spaceships?, some locals wonder.

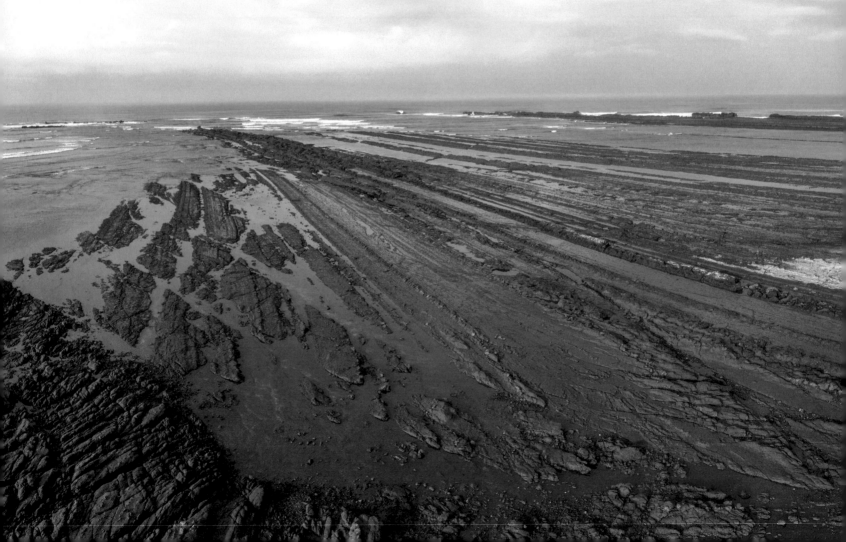

With waves that reach 13 feet, the 5 miles (8 km) of Playa Hermosa revolve around surfing. Twice, the World Surfing Championship has been held at spots along this beach, attracting surfers from around the globe.

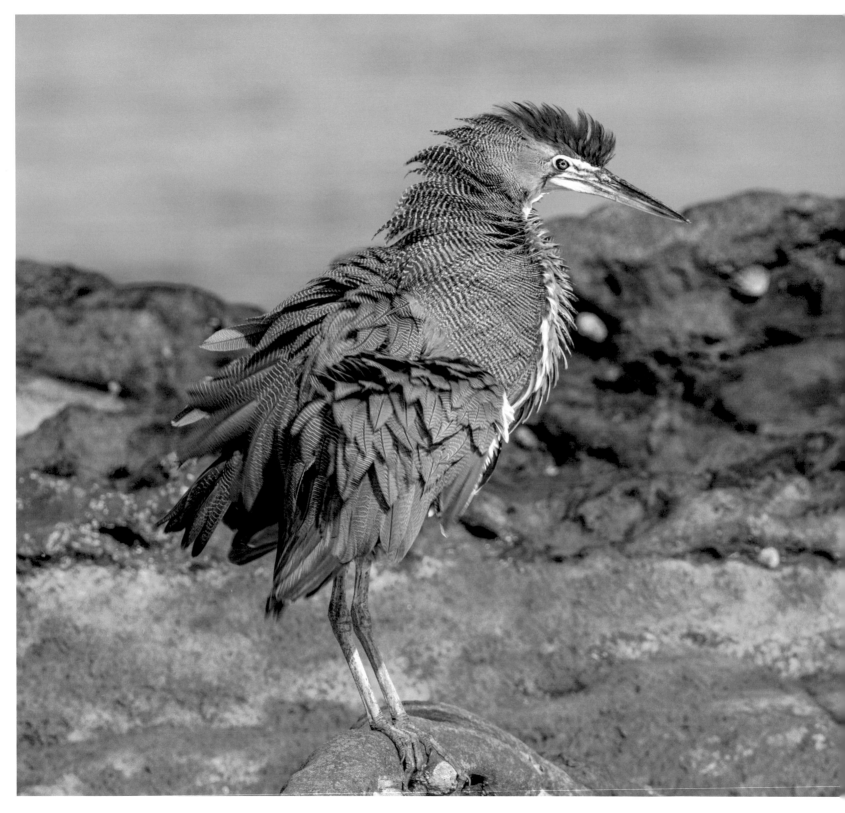

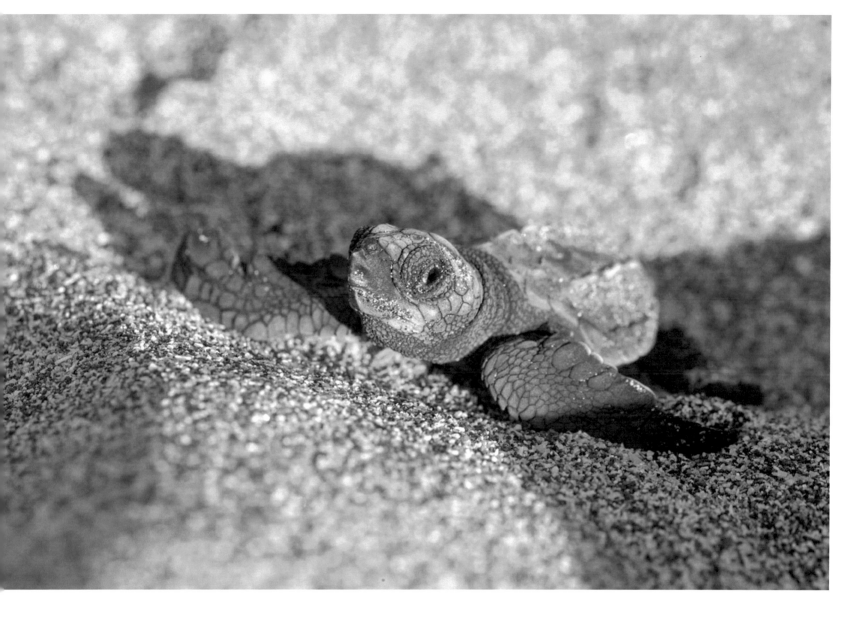

Though less known than Ostional or other beaches on the Pacific, the Playa Hermosa-Punta Mala National Wildlife Refuge is an important spot for olive ridley sea turtles (*Lepidochelys kempii*)—as many as 700 nests have been reported for a single year. Life is risky for the hatchlings, however, as they face a variety of predators, including the bare-throated tiger heron (*Tigrisoma mexicanum*).

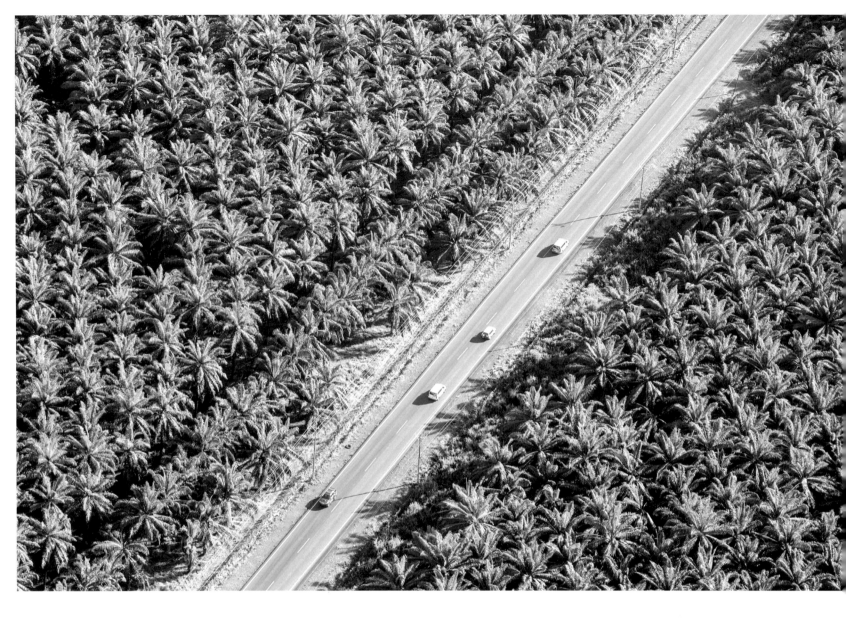

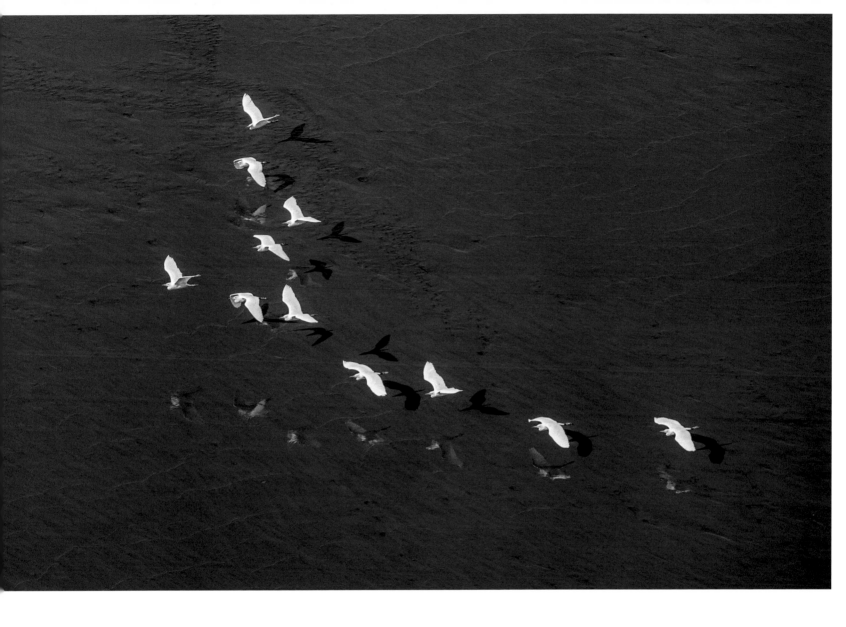

Monoculture crops have colonized the lowland plains and paved roads crisscross the plantations, yet nearby seabirds, heedless of civilization's march, still trace their ancient routes over the sand.

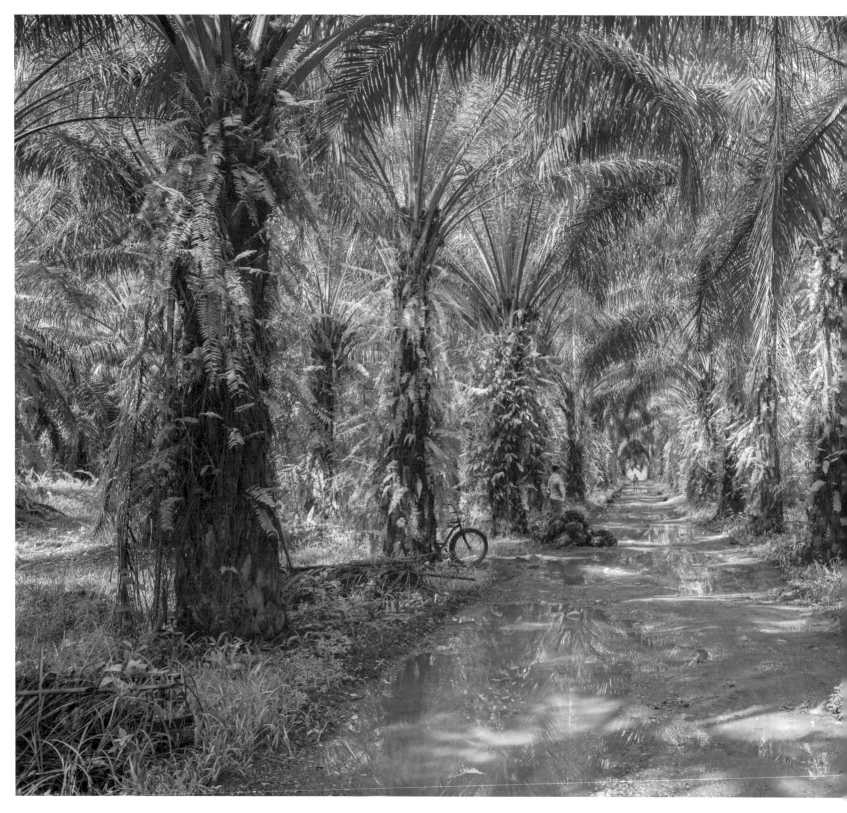

A RAPACIOUS
CROP

African oil palm plantations produce more vegetable fat than any other crop currently under production. It is a component of products as diverse as chocolate, toothpaste, cosmetics, and paint. The great demand for oil palm products has resulted in the clearing of great swaths of tropical forest, and many consider the crop the biggest threat that such forests face.

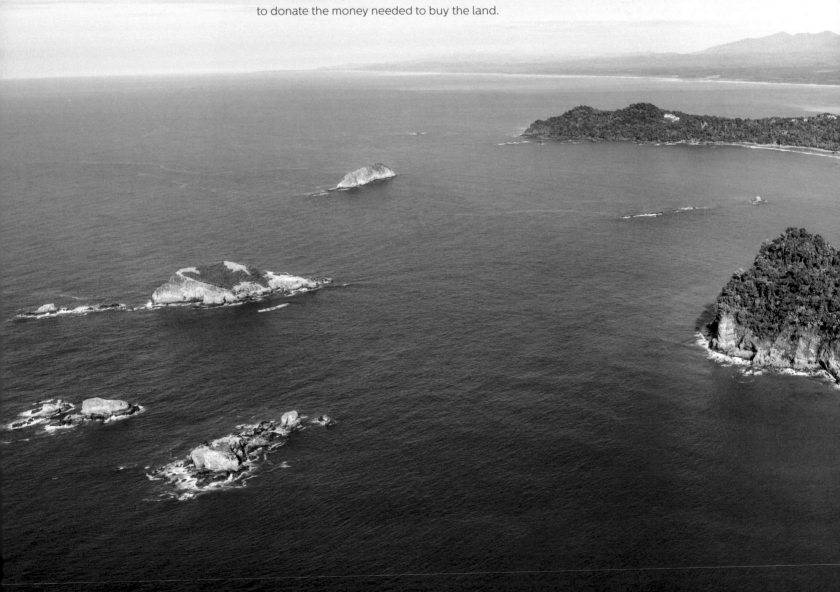

Although Manuel Antonio was declared a national park in 1972, the government lacked the funds to pay for the lands that had been expropriated. Álvaro Ugalde, former director of the National Parks

A FOREST WITH
A PRICE TAG

Department, describes having borrowed a yacht to give a group of millionaires from the US a view of Manuel Antonio from offshore. This brief sailing adventure convinced the Texan Dolly Leonhardt to donate the money needed to buy the land.

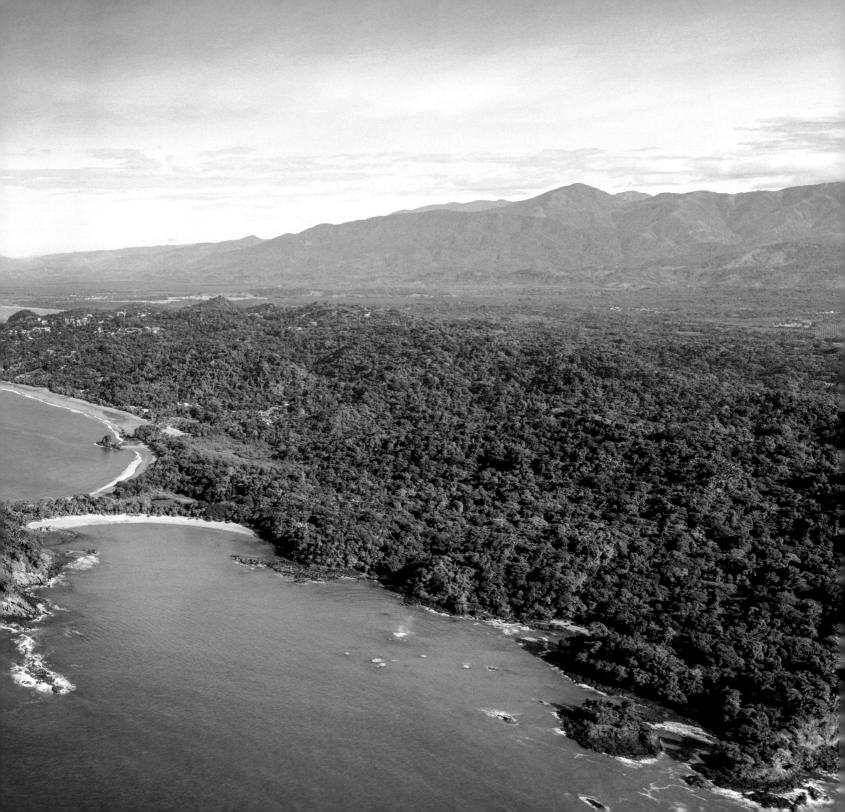

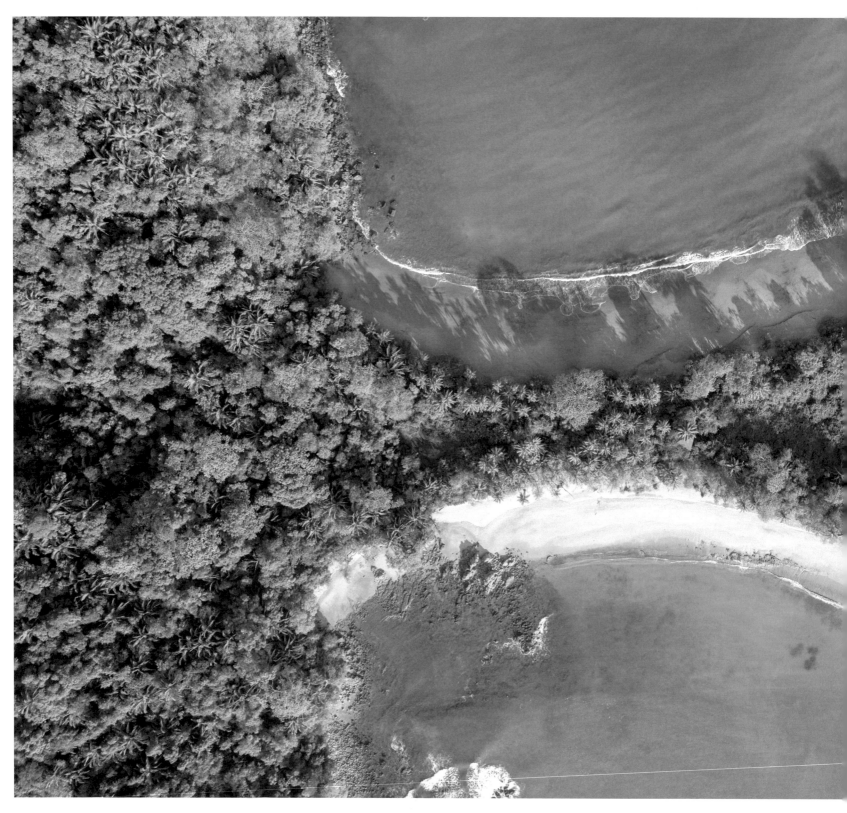

BRIDGE

Cathedral Point was once an island. Over time, the action of the waves carried sediment that created a "tongue" connecting this point with Manuel Antonio. The formation, known as a tombolo, is a nearly unique feature on the Central Pacific; a similar formation in Bahia Ballena disappears when the tide is high.

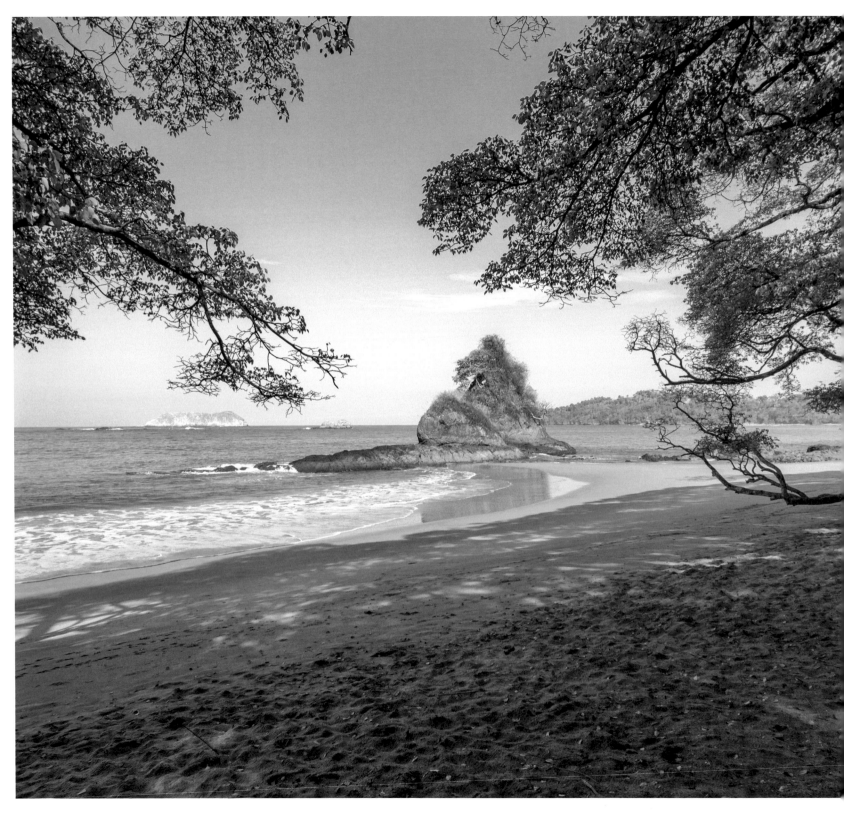

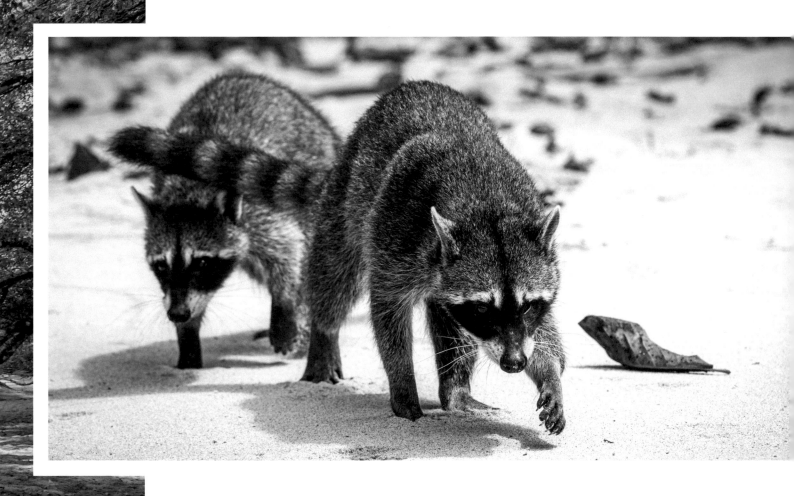

Every so often, one can see a tourist at Manuel Antonio exiting the ocean and running toward the tree line. They are chasing away raccoons (*Procyon lotor*), the most charming pickpockets in the park, adept at stealing food from people's bags.

NOISY
CREW

Squirrel monkeys have a highly fragmented habitat and occur only in the Central Pacific of Costa Rica and in western Panama. The Grande de Térraba River divides their population into two subspecies: *Saimiri oerstedii citrinellus* (pictured), grayer and paler, on the north side, and *Saimiri oerstedii oerstedii* on the south side.

In Manuel Antonio, it is common to come upon troops of up to 40 individuals jumping noisily between branches, turning over leaves in search of insects.

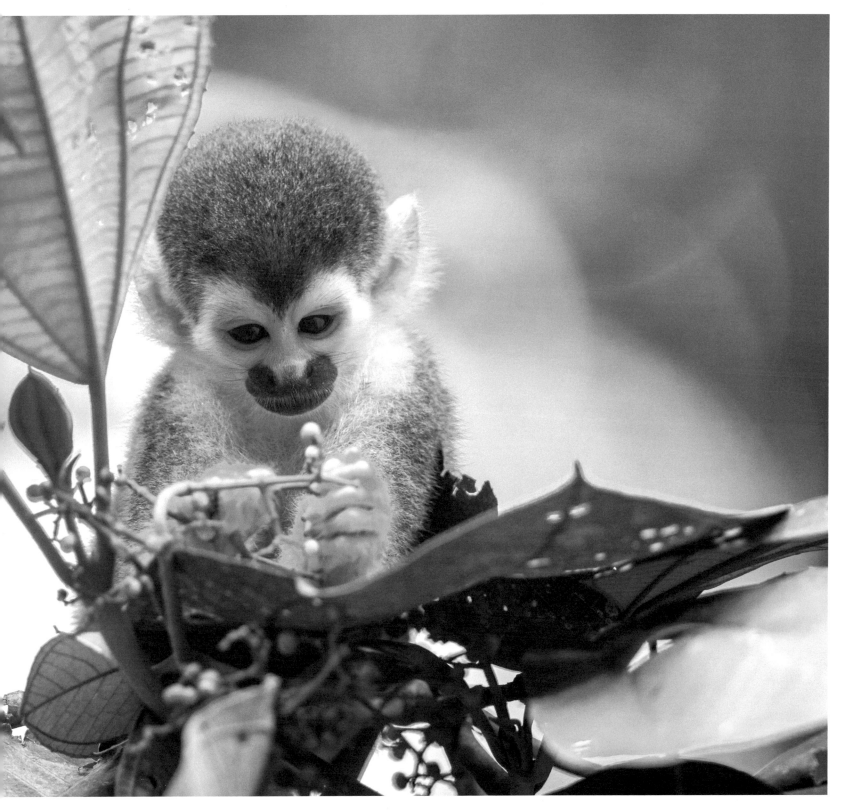

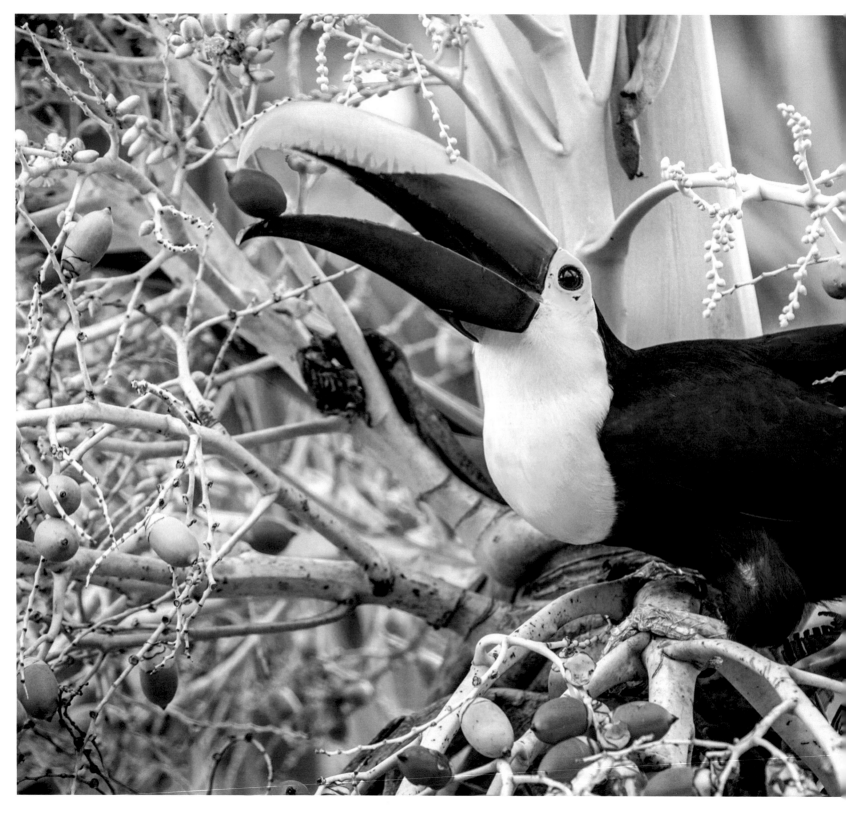

A HANDY
BEAK

The chestnut-mandibled toucan (*Ramphastos ambiguus swainsonii*) is the largest of the six species of toucans in Costa Rica. Its most interesting feature, however, is its beak. When temperatures rise, the beak absorbs heat, allowing the bird to maintain a stable temperature. How does this work? The beak contains an abundant network of blood cells that allow it to function as a natural radiator.

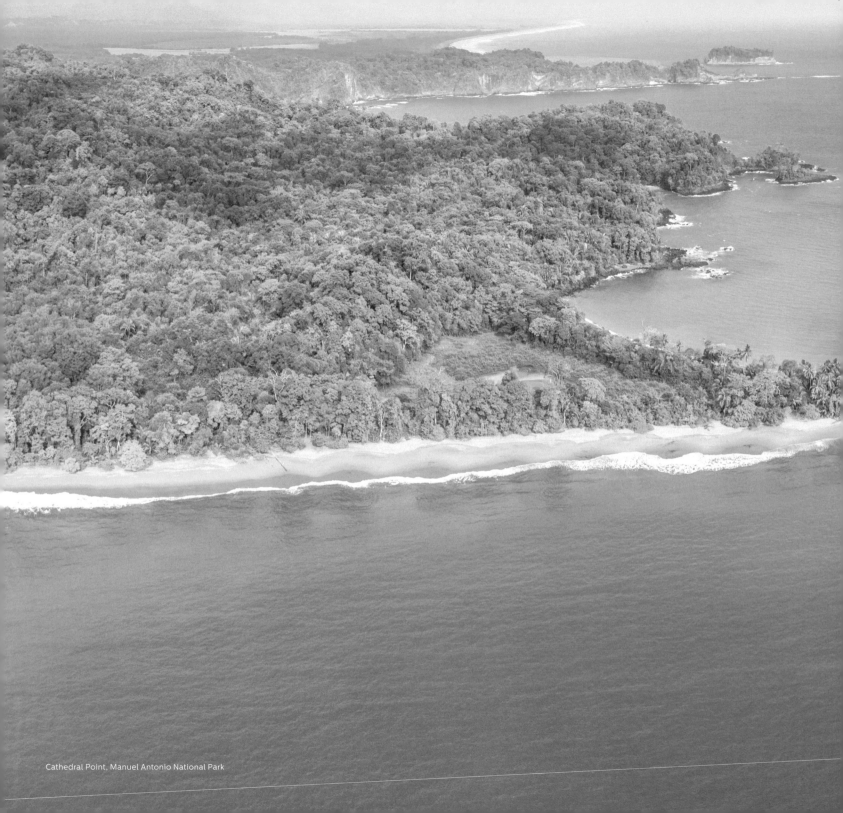

Cathedral Point, Manuel Antonio National Park

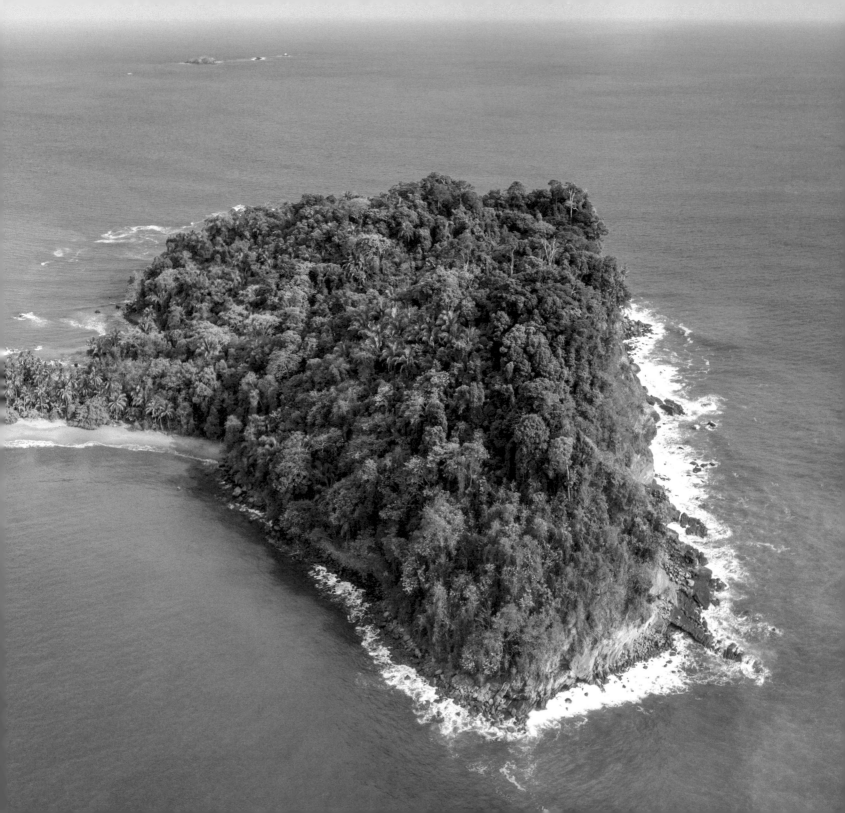

THE
WHALES'
ROUTE

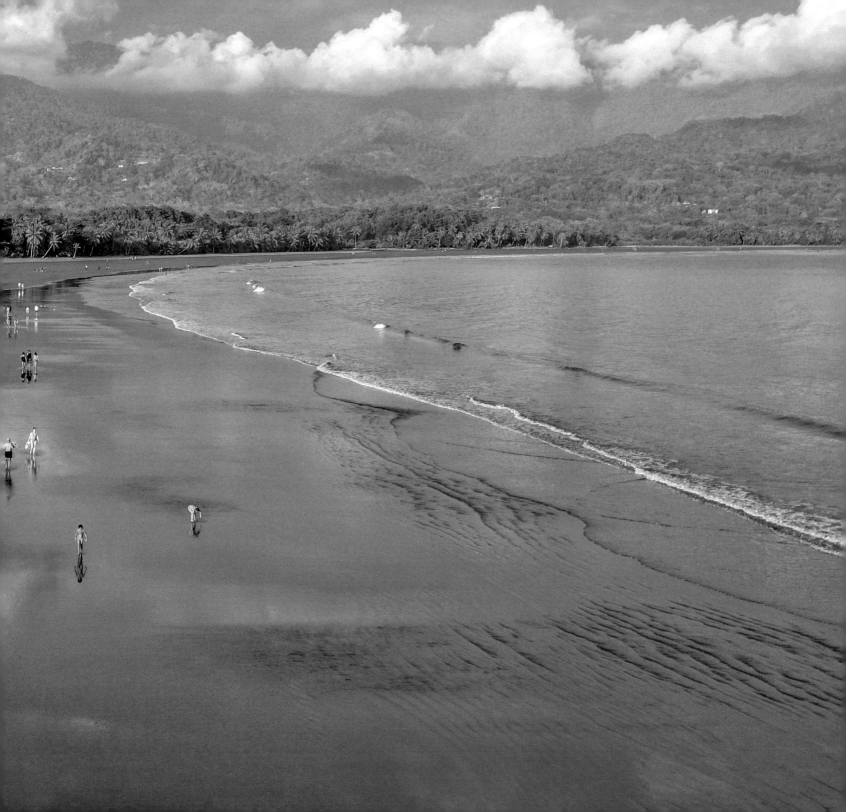

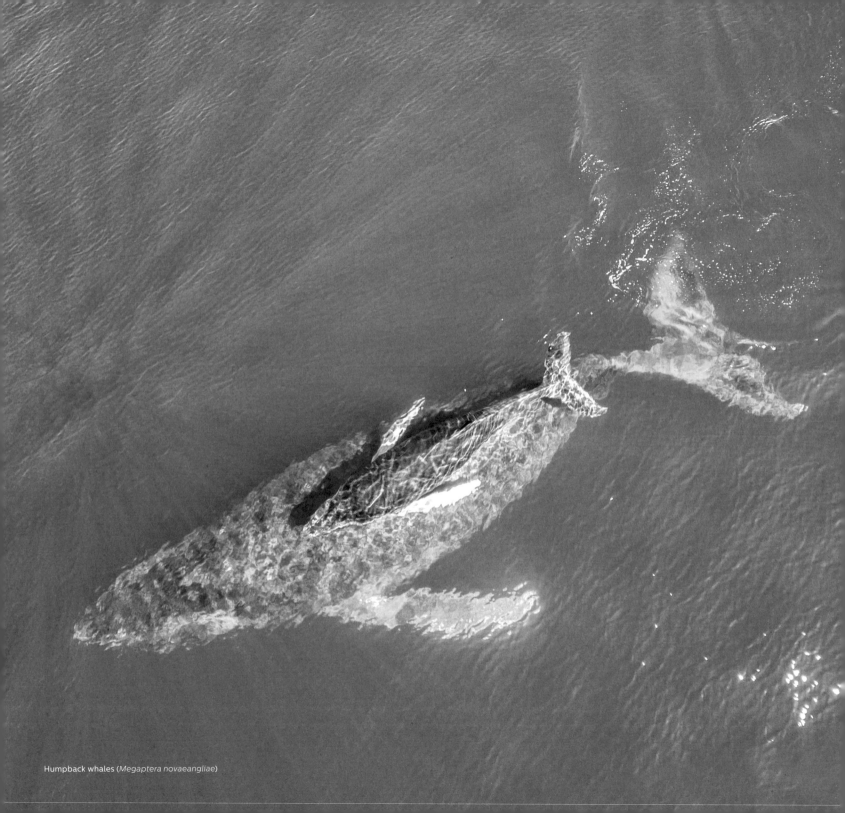

Humpback whales (*Megaptera novaeangliae*)

It sounds far away initially, but the rattling noise, coming from beyond the trees, is getting closer. As it nears the beach, the source of the sound is identified: it is the hum of pistons, a foreign element in this coastal forest. An invader, perhaps. Finally, the foliage parts to reveal the metallic shell of a red tractor towing a boat toward Playa Uvita, in Marino Ballena National Park.

A few decades ago, that sound would have been a bad omen. Tractors had a different purpose in this region, bordered on the north by the Savegre River and on the south by the first islands in the Grande de Térraba River delta. Then it was an agricultural zone where farmers uprooted bushes and trees to extend their cropland and pastures, cutting farther into the forest each year. There were other sounds, too: axes chopping wood, the crash of trees falling to the ground, the sound of birds taking flight, and, liminally, the sighs of a dying jungle.

On this strip of land between the Brunqueña Mountains and the Pacific Ocean, daily life—up to the end of 1980s—was very different from today. Tractors tore down the jungle and each morning boats stirred from the coast to set out their nets. But over time, the region's inhabitants began to take note of the dozens of tourists interested in photographing monkeys, frogs, and whales. Then there were hundreds. Later yet there were thousands. Around Marino Ballena, the tractors were diverted to new uses, and boats no longer carried fishing nets. Today they carry groups of tourists to view capering humpback whales (*Megaptera novaeangliae*).

The clearest evidence of this transformation is the national park itself, established by decree in 1992. A few years before it was designated a protected area, this was a relatively unknown stretch of coast dedicated to fishing. Now it is the fourth most visited

national park in the country, after Manuel Antonio, Poás, and Irazú.

Here you can find two sets of visitors: tourists bedecked with cameras, and the whales they come to see. The marine section of the park—nearly 13,000 acres (5260 hectares) of protected area—is considered one of the best places in the world to watch whales, explains Catalina Molina, director of the Keto Foundation, a source of authoritative information on the cetaceans that live in this region.

The presence of these marine mammals was fundamental in justifying the creation of the first marine protected area in Central America. Scientists and local conservationists worked together to photograph the tails of the various cetaceans. Each displays a unique pattern and thus functions as a sort of fingerprint. This was how they learned that, from December to February, humpback whales arrive from the west coast of the United States and, between June and October, other individuals arrive from the freezing waters of Antarctica and Tierra del Fuego. In addition to humpback whales, the waters of Marino Ballena also attract spotted dolphins (*Stenella attenuata*), bottlenose dolphins (*Tursiops truncatus*), and rough-toothed dolphins (*Steno bredanensis*).

The collection of scientific data continues. The Keto Foundation works with boat captains and guides, who identify species, count their numbers, and observe their behaviors. This is a great benefit to scientists who otherwise would have to pay expensive boat rental fees; at the same time, the boat captains and guides benefit from the tourism the scientific research helps to bring in. The guides provide the data, the biologists analyze it. Molina explains that humpback whales are an "umbrella species," which is to say that if you protect them, you also protect coral reefs, sea turtles, and mollusks hidden among the rocks.

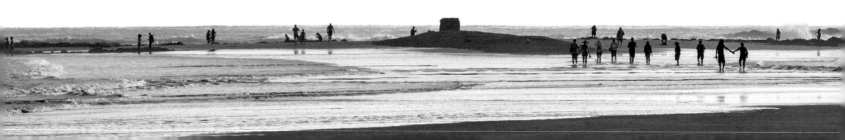

There is another cetacean of sorts in the park, who often remains hidden. When the tide is low, a sand bridge is uncovered between Punta Uvita and a cluster of rocks and reefs offshore. Seen from above, the formation strikingly resembles a whale's tail.

If you walk to the rock, about half a mile from the point, and turn around toward shore, you see a giant green wall—the Brunqueña Mountains—that serves as a barrier to the rest of the country.

In the early 1900s, this region was practically uninhabited, with only a few families nestled between the waves and the mountains; it wasn't until the 1920s that the number of boatmen who traded between Puntarenas in the north and Ciudad Cortés in the south, then called El Pozo, began to increase. The captains of these boats would load agricultural products in Dominical and Uvita and head to Puntarenas to sell their cargo; they would take with them shopping lists from residents for goods that could not be obtained locally.

In 1941, a ship arrived with another kind of cargo, work vehicles that belonged to the Charles E. Mills Construction Company, a US enterprise that had been contracted to build the southern section of the Pan-American Highway. The North American engineers sent their machinery into the mountains and established the first road to San Isidro de Pérez Zeledón, replacing the horse trail that had tied together the two places. From San Isidro, the company began building north and south, to focus on the main goal of the project. In fact, they did not pave the road connecting the beach and towns inland until 1986, which kept this area relatively isolated.

As a result, up until the second half of the 20th century, this region remained blissfully disconnected from the rest of the country and far from Osa, Quepos, Dota, and Pérez Zeledón, the closest towns offering municipal services.

While there was no electricity, there were also no municipal tax collectors. Playa Uvita had a scare when Alcoa

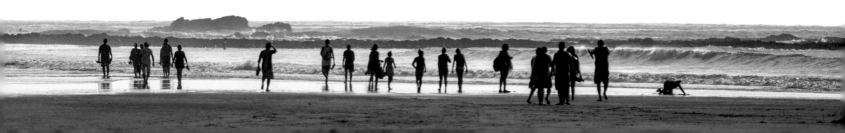

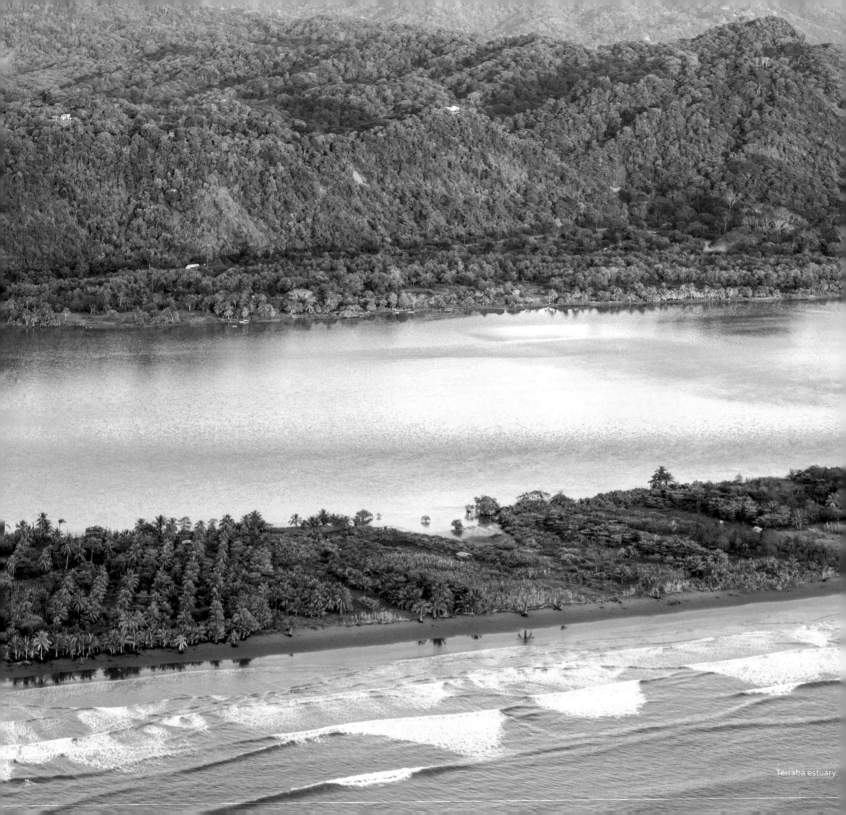

Térraba estuary

Mining, a US company, bought Hacienda Bahía, the principal estate in the region, promising to build a port to export the aluminum it planned to mine from the mountains. In 1970, protests halted the project, and Alcoa Mining left the region; to this day, Costa Ricans celebrate the Alcoa protests as the first great victory for environmentalists. In a small country that had been primarily agricultural, an entire generation discovered environmental activism.

With or without a mine, the land was changing. Encounters with tapirs and jaguars, once common, were now fading memories. Locals recounted stories from their grandparents, who would take their pigs by land to sell in San Isidro or Ciudad Cortés and would usually lose one or two to the "tigers," as jaguars were commonly called. Farmers continued with their practices, demolishing forest and expanding their pastures. They were ruthlessly efficient.

According to a study done by the National University of Costa Rica (UNA), the forest cover in the region went from 78% in 1960 to just over 57% in 1972; the animals fled inland, seeking refuge in the Brunqueña Mountains.

The lands to the north of the Barú River and, beyond it, the Marino Ballena protected area, suffered a similar fate. On an extensive 815-acre (330-hectares) farm that stretched from the beach up the Brunqueña Mountains, only the steep slopes of the mountain still had forest remnants. While workers led cattle across the barren plains, wildlife sought refuge in the hills above. Here, the resistance was born.

Trees are patient. They live on a time scale that is foreign to humans. A gringo who arrived in 1972 to manage this farm carried with him ideas that seemed strange to many. He prohibited hunting on his land, for example. Jack Ewing started to transform his cattle farm into a forest that would eventually become the Hacienda Barú National Wildlife Refuge. When he gave them space, the trees started to come down from the mountains and reforest the plains. Now they cover almost the entire farm. Jack Ewing remembers a friend who told him that in Costa Rica, "when you stop cutting back the brush, the jungle comes back with a vengeance."

And forest would return to other regions of the coast. The National University

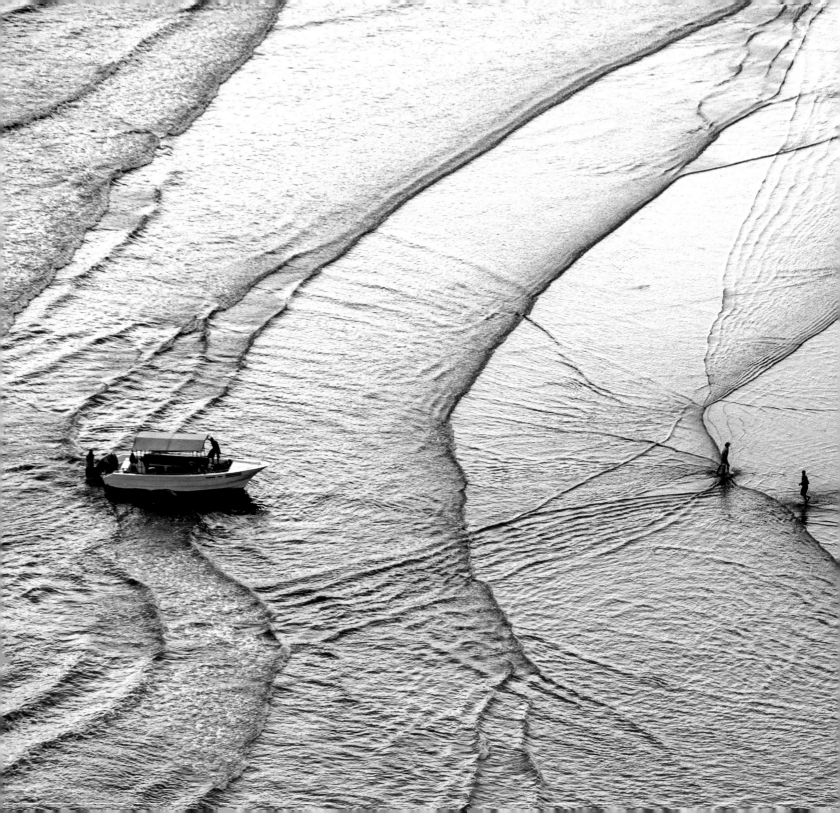

Whale watching in Bahía Ballena.

of Costa Rica reports that, by 2007, 72% of the region had forest cover, partly because some farmers had abandoned agriculture due to market conditions but also because of "crazy" people like Ewing. With the return of the forest, the spider monkeys also returned, as well as the cries of howler monkeys. And so too puma tracks in the highlands, where they are spied on by camera traps.

With the opening of the last big regional highway, the Costanera Sur, these conservation victories are being put to the test. The section between Dominical and Quepos was inaugurated in 2010 and this increased the number of tourists who come to watch whales or hear the sounds of the coastal forest, putting pressure on local resources. And as the number of visitors increases, so do the local fleet of tractors carrying boats that meander across Playa Uvita. Nonetheless, for the time being, the delicate balance between ecotourism and conservation sustains itself. On the beach, the tractor retraces its path along the sand, its task accomplished, and escapes among the trees until its metallic clashing song is swallowed by the forest. Today there is nothing to fear.

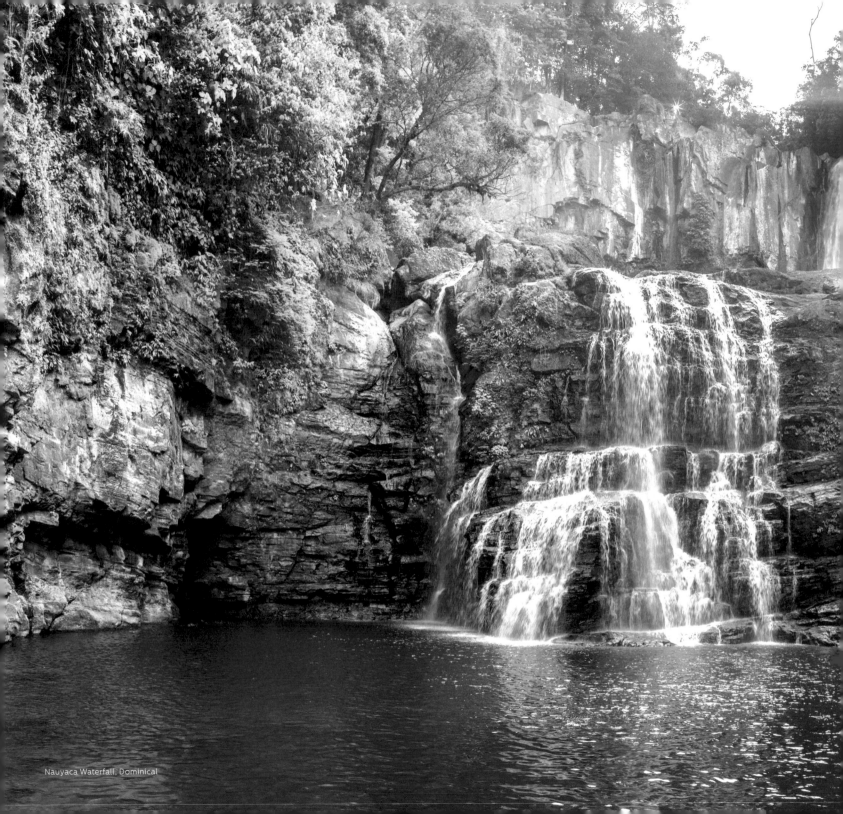

Nauyaca Waterfall, Dominical

CURTAIN OF
WATER

Nauyaca Waterfall, the most visited waterfall in the Central Pacific, is actually two waterfalls. The tallest—pictured—cascades down 150 feet (45 m), while the other is a gradual 65-foot (20-m) drop that ends in a pool where tourists gather, sitting beneath the falling water or diving down below the surface.

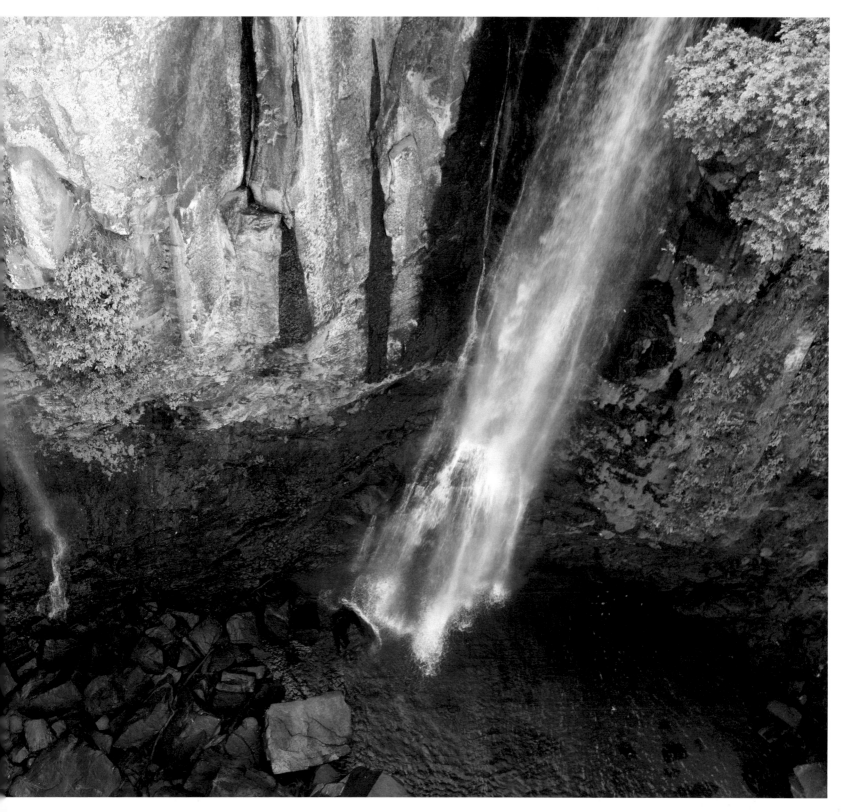

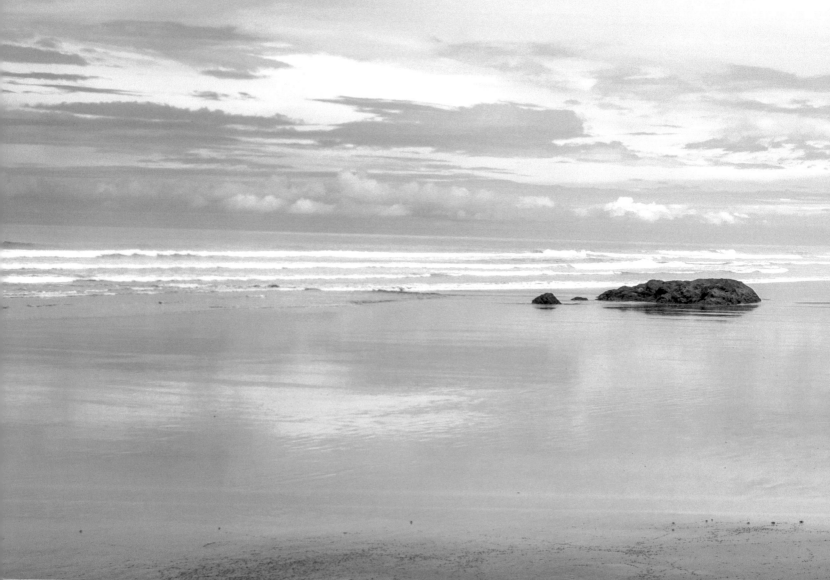

TROPICAL
IMPRESSIONISM

Here, low tide creates mirrors of humid sand that reflect the rays of the sun at dawn or dusk. While many come to Dominical to surf, its beaches are also an ideal spot for a morning walk.

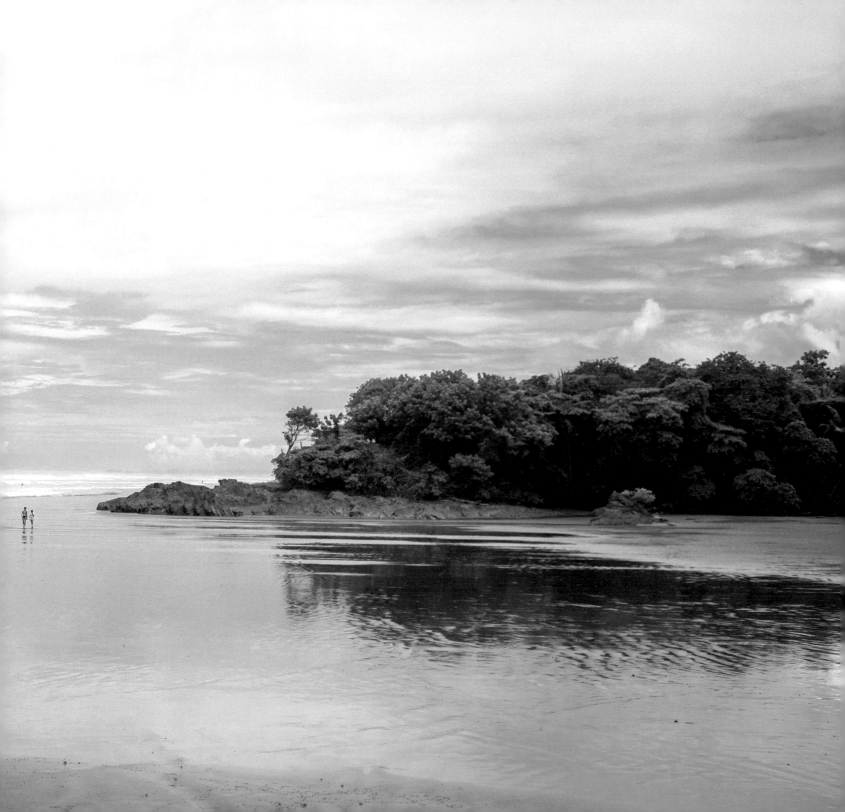

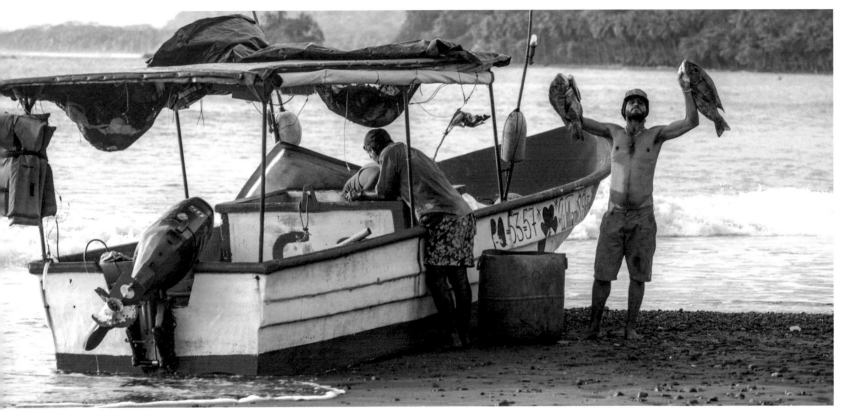

The Barú River separates the forest of the Hacienda Barú National Wildlife Refuge, on the north side, from the small fishing village of Dominical, on the south side. The refuge was crucial in staying the advance of the agricultural lands to the north. People in the community of Dominical are slowly giving up fishing for tourism as a source of income.

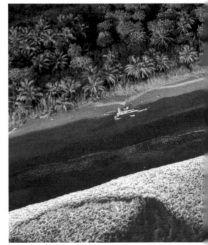

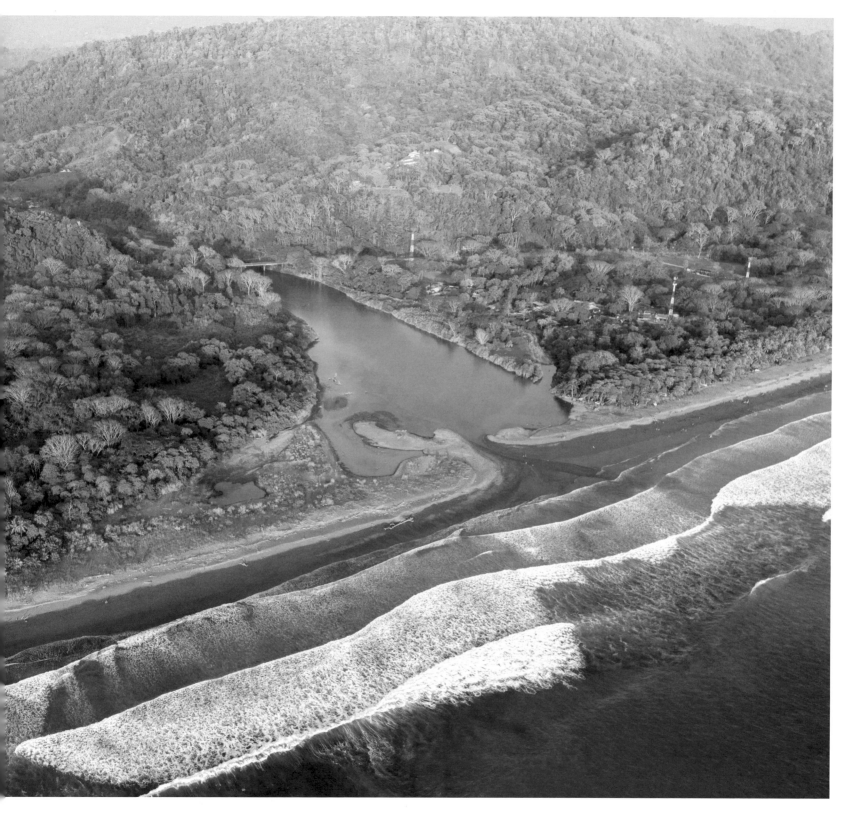

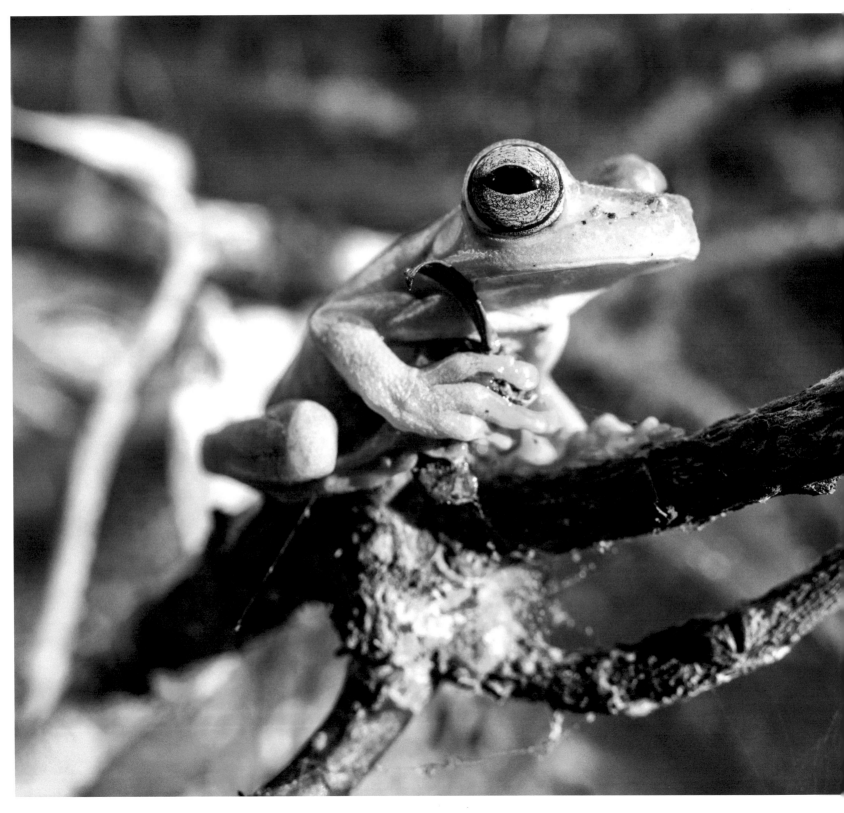

UNUSUAL
COLORS

This juvenile *Boana rosenbergi*, photographed in the Barú Biological Refuge, shows a unique, spectacular feature: its eyes are emerald-green rather than the usual silver or bronze. While green eyes do sometimes appear on closely related *Boana* frogs in South America, this is the first time it has been observed in either of the two species that occur in Costa Rica.

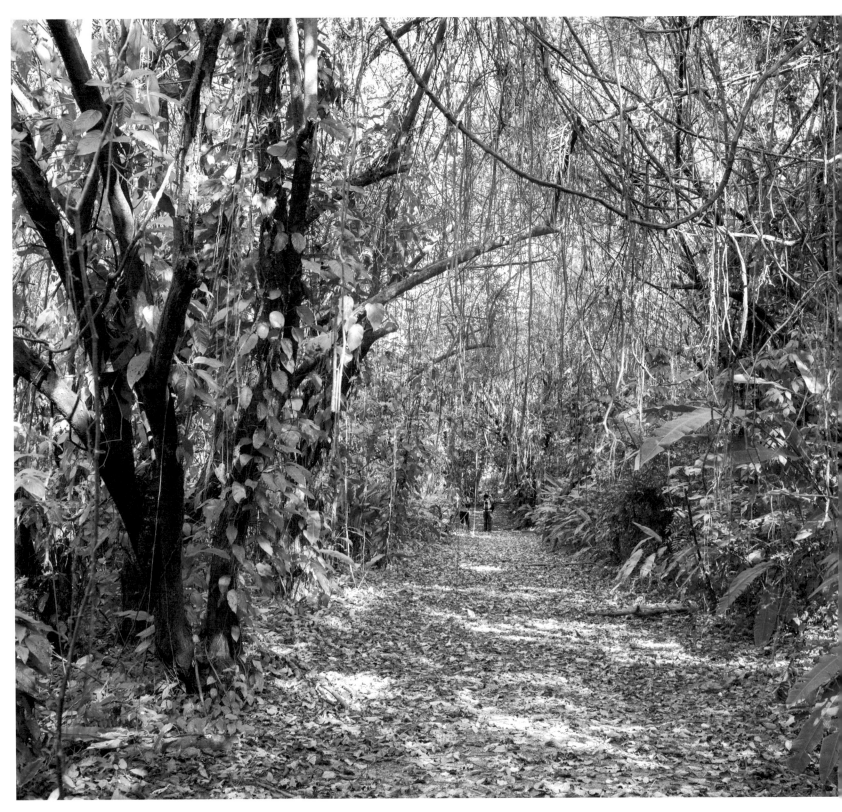

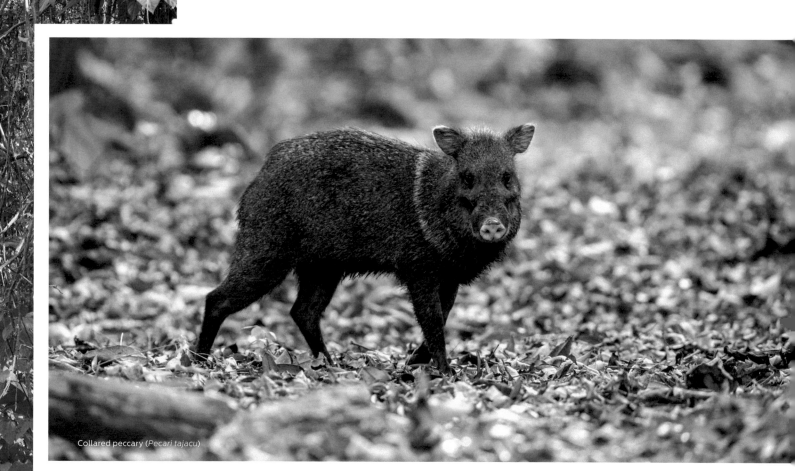

Collared peccary (*Pecari tajacu*)

When Jack Ewing arrived at Hacienda Barú in 1972, he found a cattle farm and a mountain that was losing more forest cover each year. In 1979, he started with one steep pasture, on which he stopped cutting the grass and planted a few native tree species. Thus began a transformation that would return the northern side of the Barú River to its current untamed state.

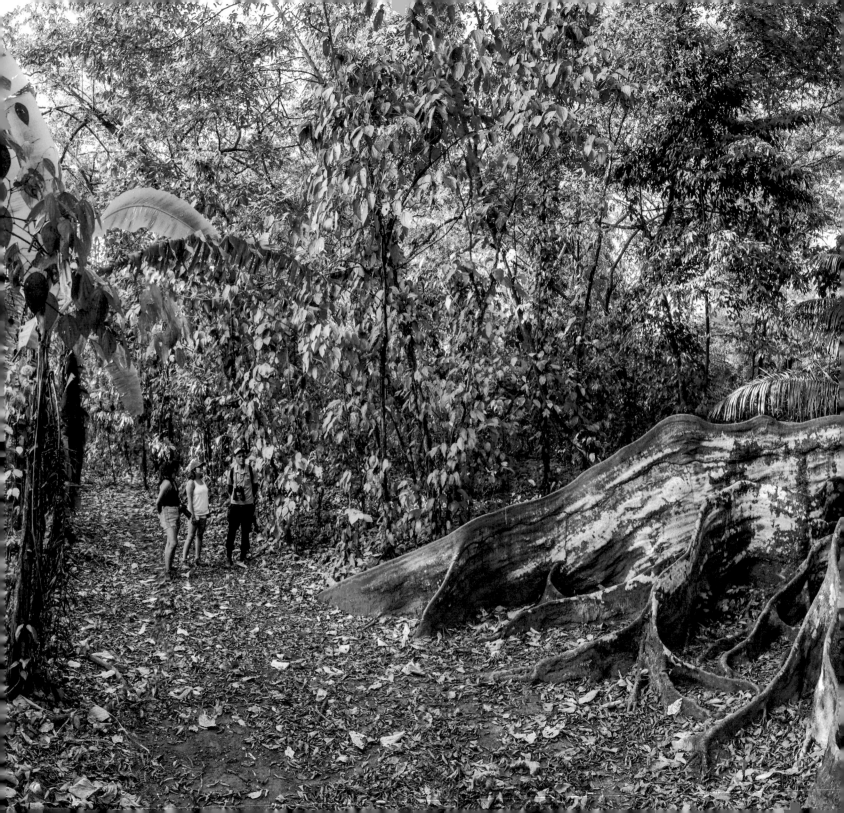

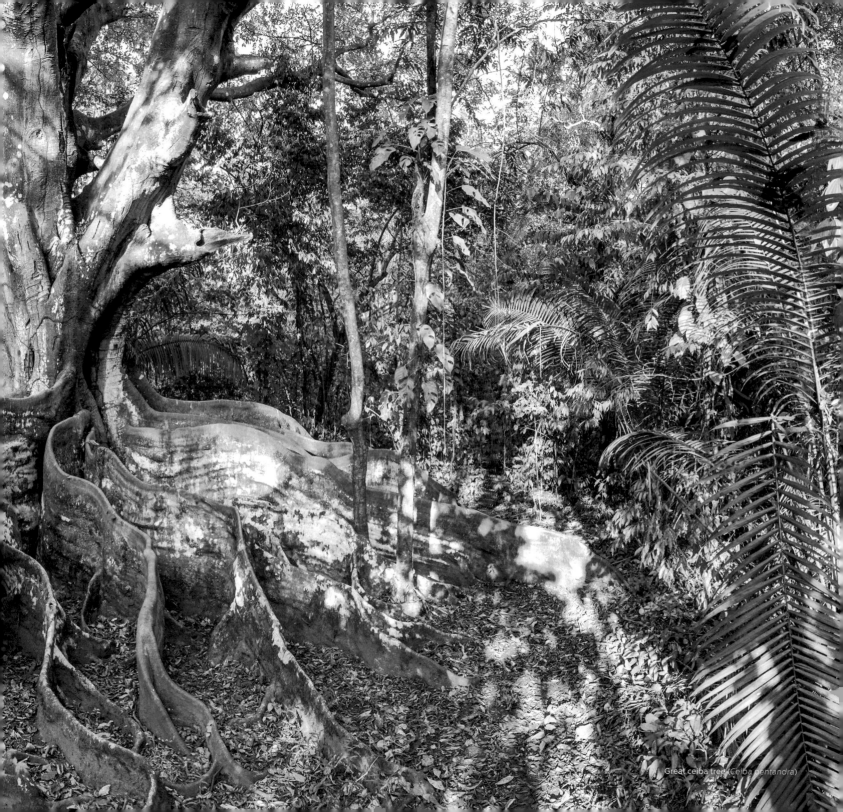

Great ceiba tree (Ceiba pentandra)

NEW
FRONTIERS

As the country loses forest cover, species react in distinct ways. When forests shrink, for example, populations of the small bat falcon decline, while populations of the yellow-headed caracara, which thrives in open areas, grow. A few decades ago, the caracara could only be seen in Panama, but today it can be found as far north as the Gulf of Nicoya.

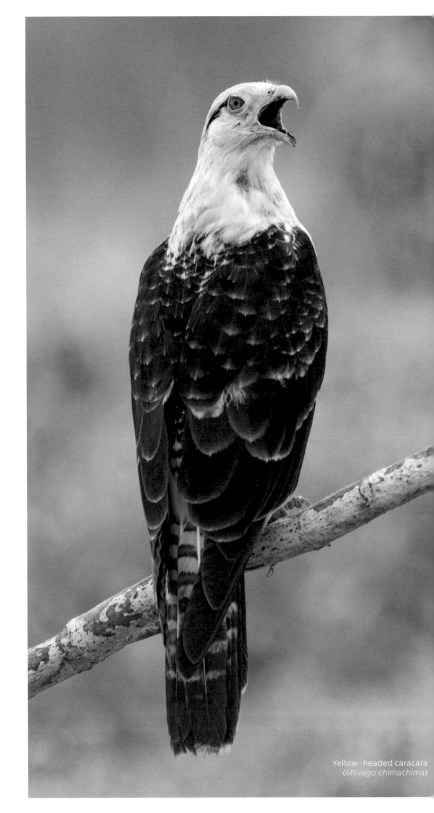

Yellow-headed caracara
(*Milvago chimachima*)

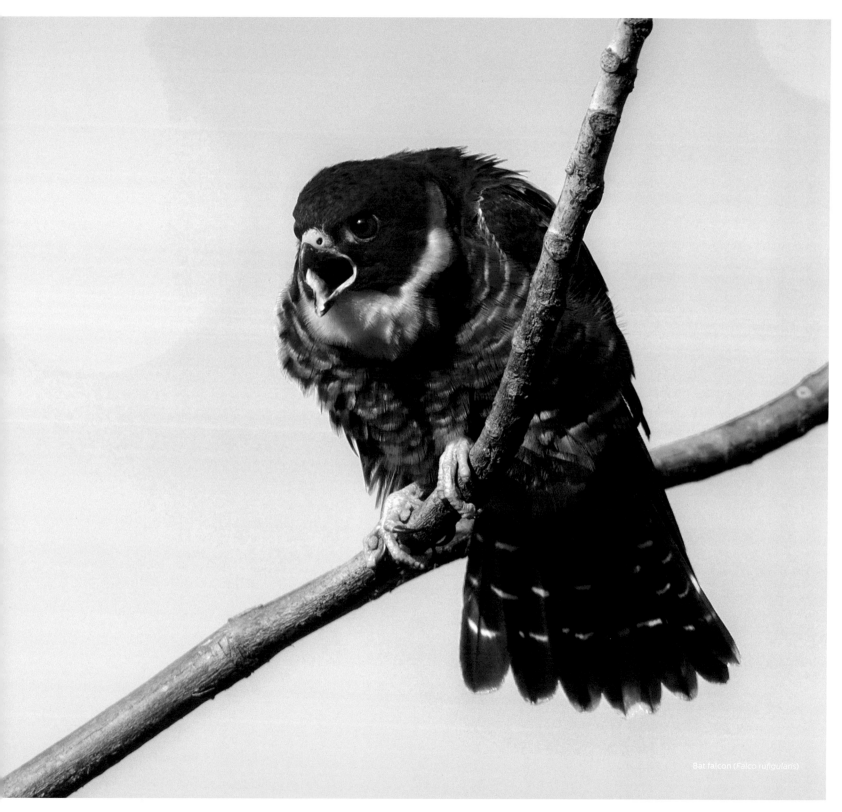

Bat falcon (*Falco rufigularis*)

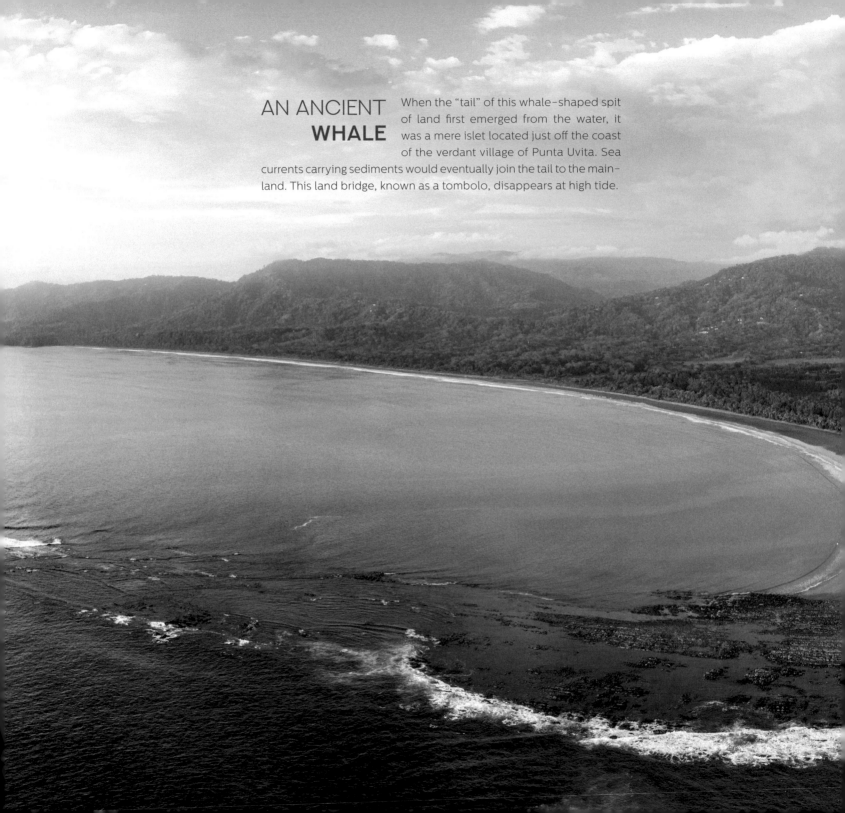

AN ANCIENT **WHALE**

When the "tail" of this whale-shaped spit of land first emerged from the water, it was a mere islet located just off the coast of the verdant village of Punta Uvita. Sea currents carrying sediments would eventually join the tail to the main-land. This land bridge, known as a tombolo, disappears at high tide.

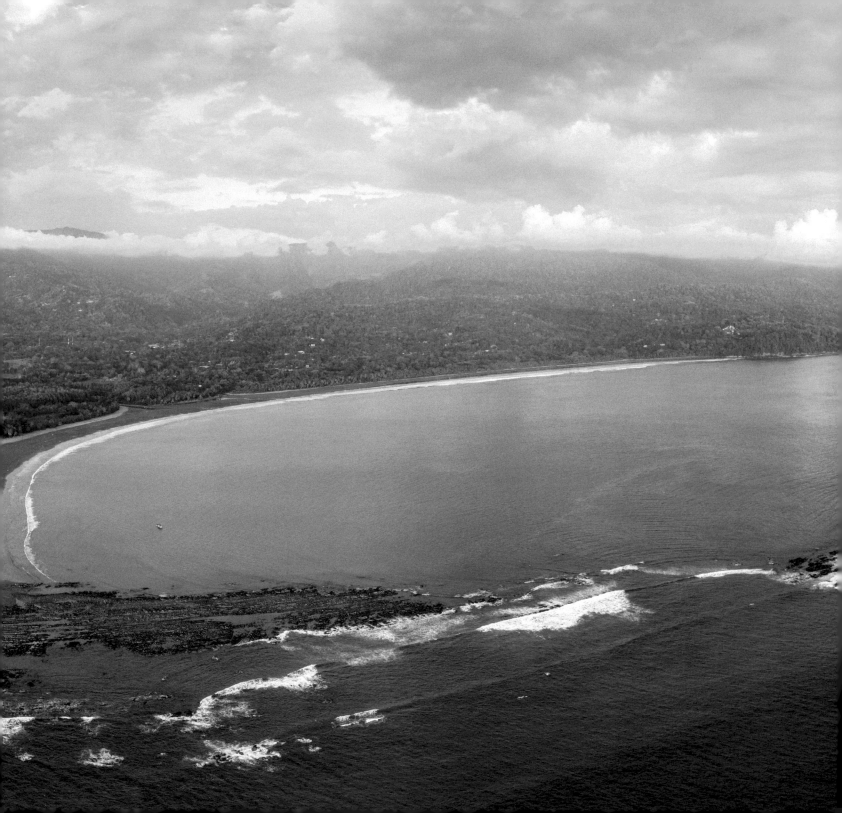

EMERGENT LANDS

The Bahia Ballena tombolo, with the sea gently lapping against the sand on the left and the right, suggests in miniature the geological history of Costa Rica. Several million years ago, the country emerged from the depths of the ocean, creating a land bridge between North and South America.

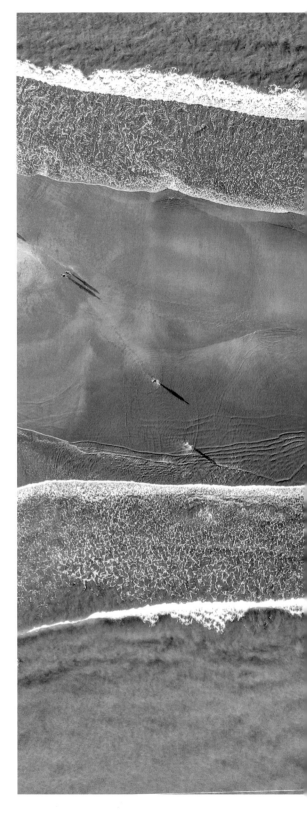

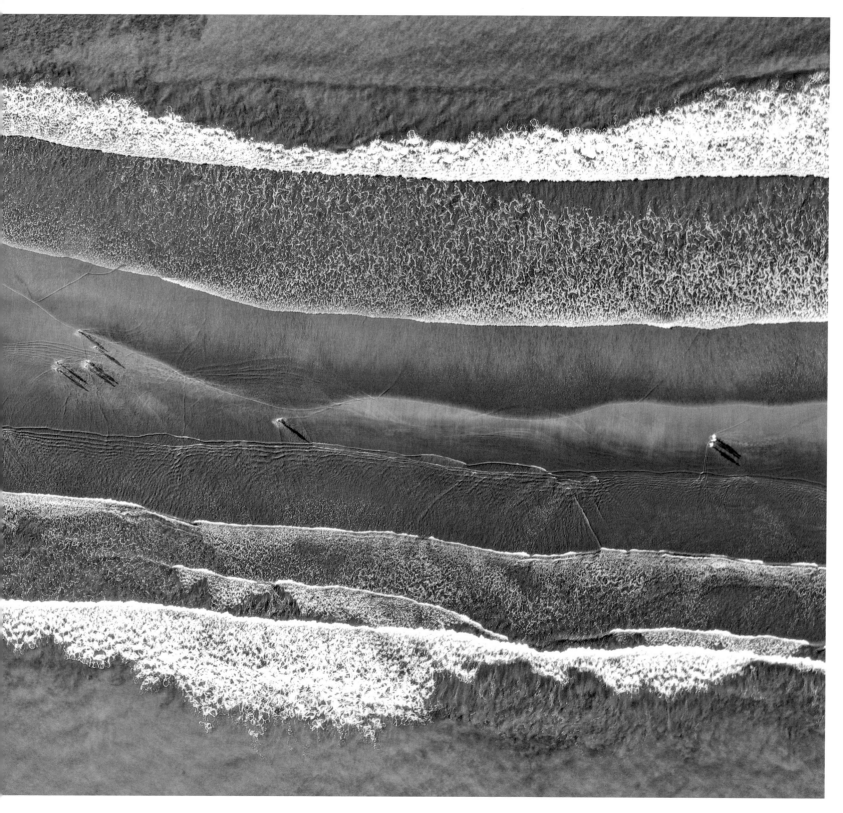

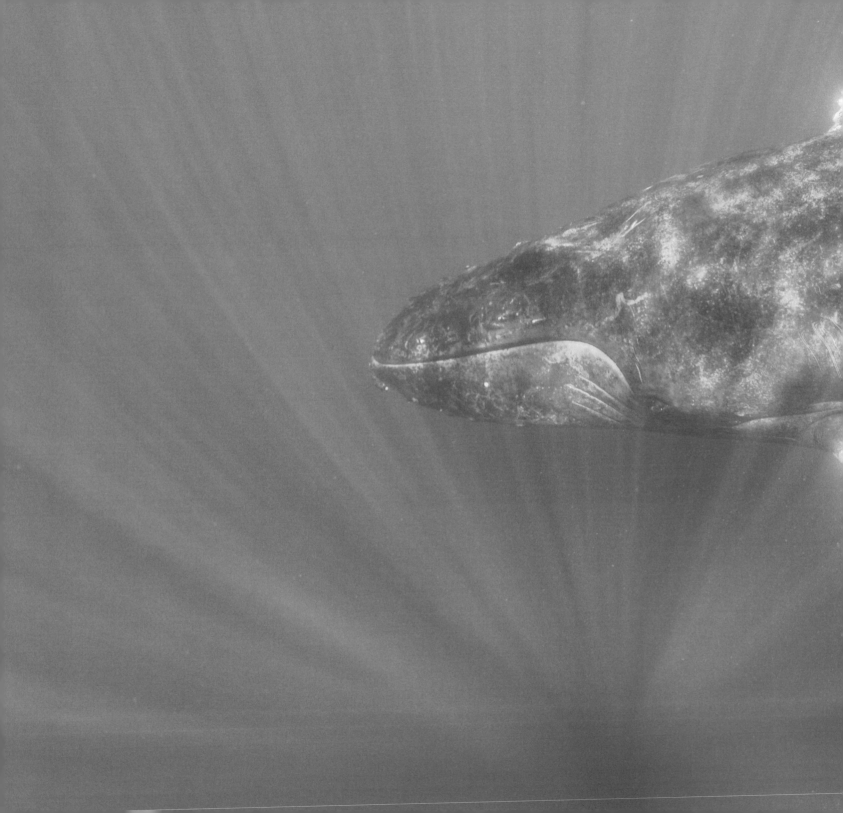

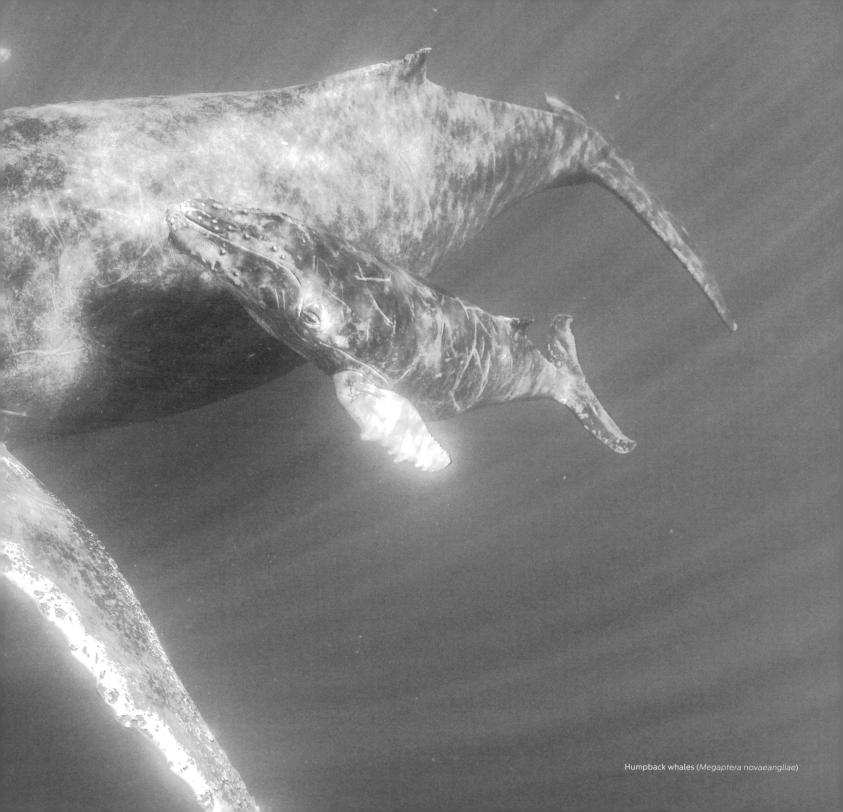

Humpback whales (*Megaptera novaeangliae*)

WINDOWS TO THE SEA

The persistent action of waves carved out a passage
in this rock on Ventanas Beach (*ventana* means window).
At low tide, you can walk through this passage and watch
the breaking waves from within.

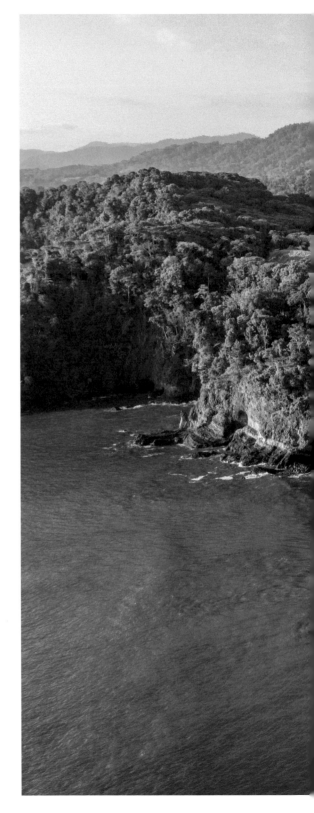

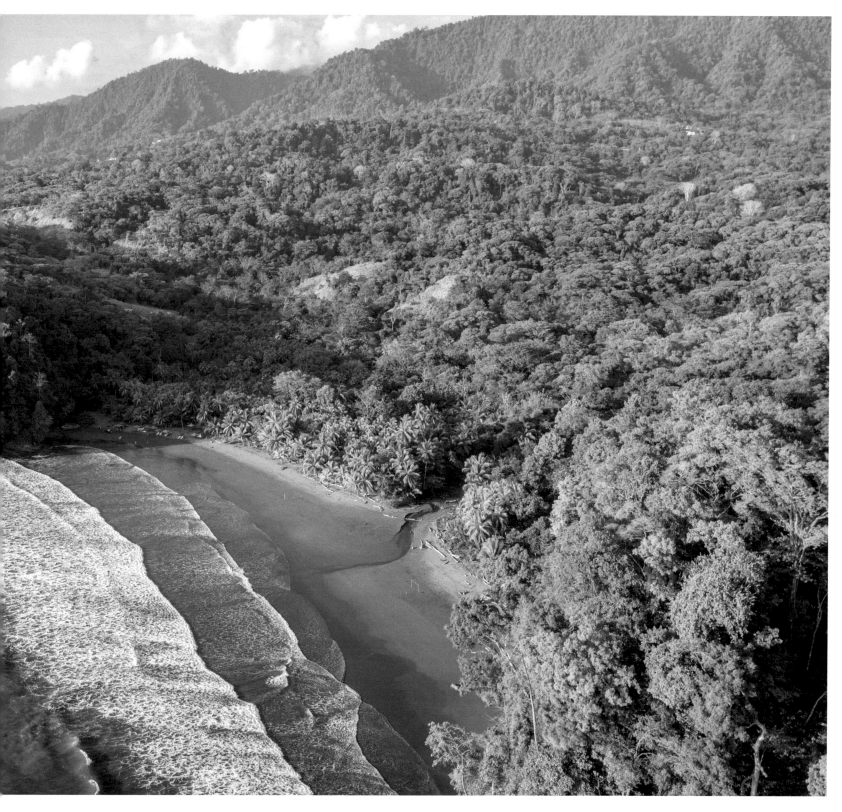

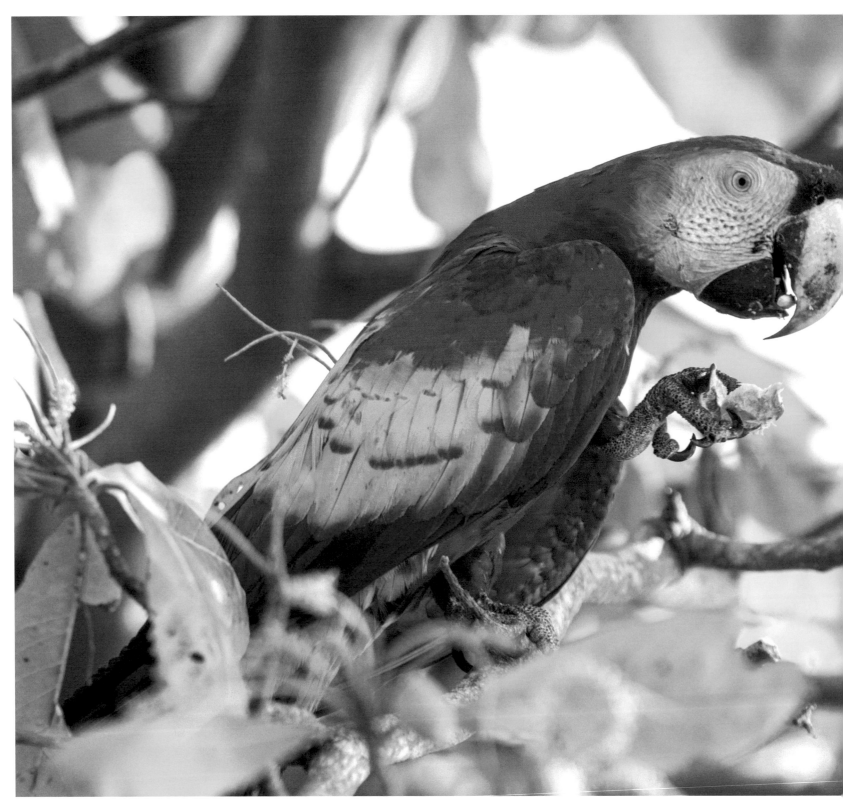

The scarlet macaw (*Ara macao*) returned to Bahía Ballena decades after having disappeared from the area, while the northern royal flycatcher (*Onychorhynchus mexicanus*) lived here all along.

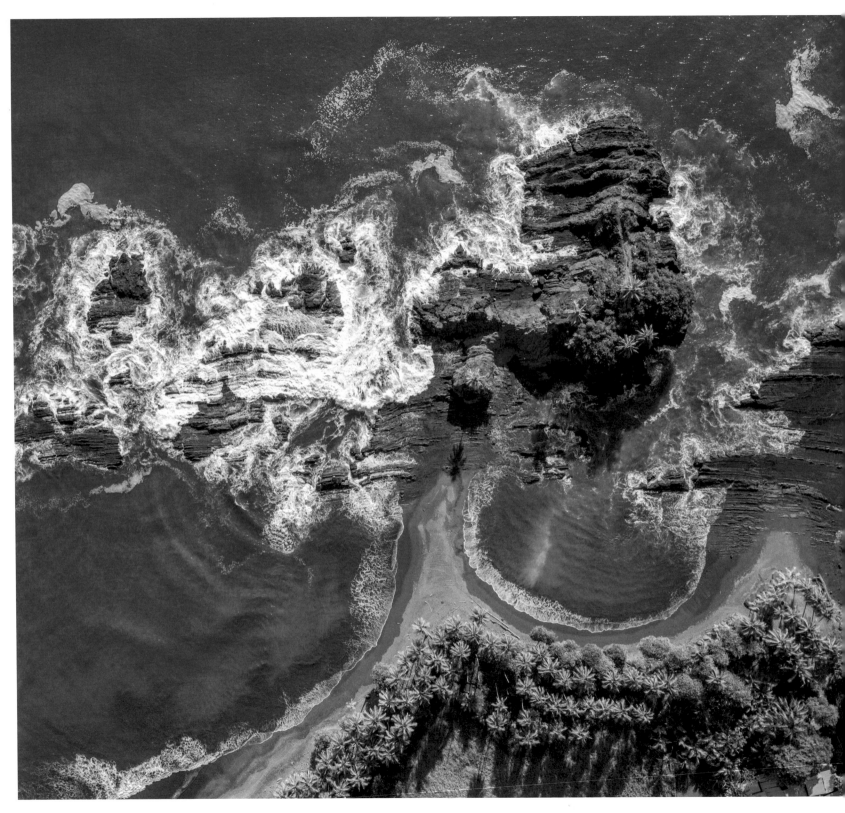

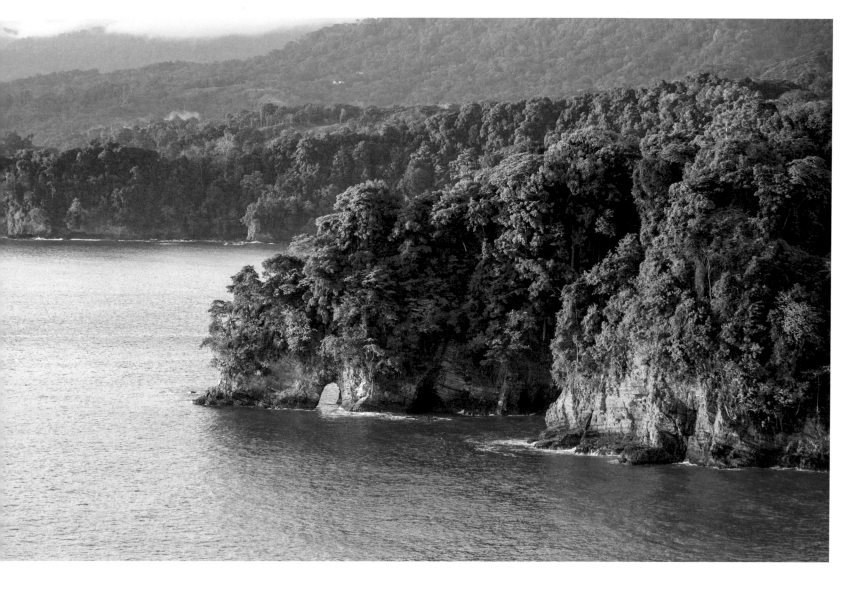

The flora of the Central Pacific is exuberant, with trees that manage to grow directly on rocks, defying gravity and caressing the waves with their branches.

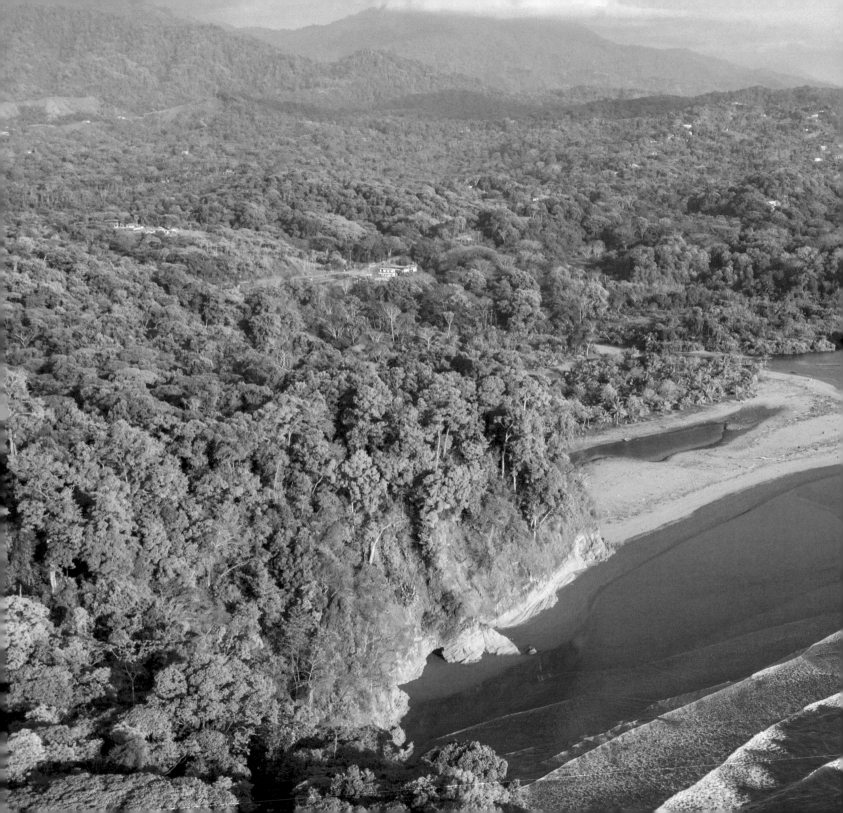

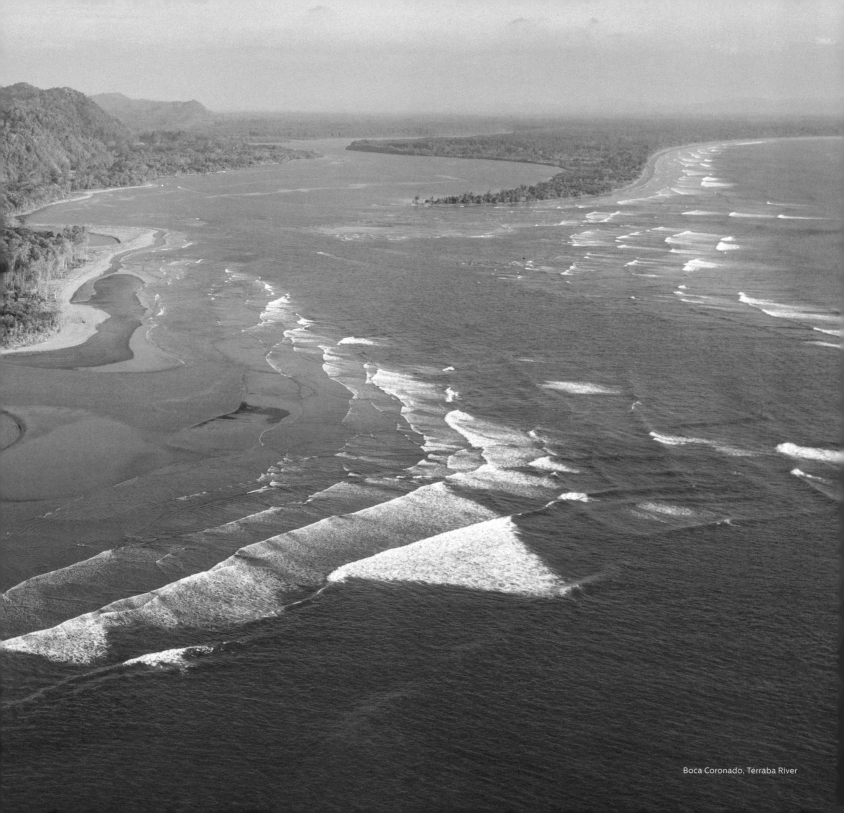

Boca Coronado, Térraba River

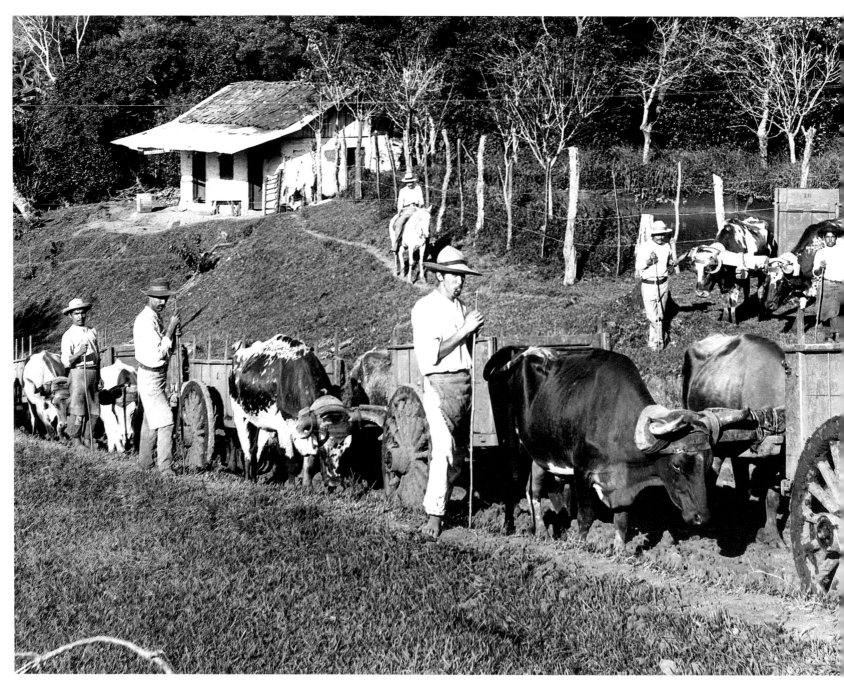

This oxcart trail used to connect the port of Puntarenas with the Central Valley (unknown photographer, approximately 1920)

INDEX

CREDITS

PHOTOGRAPHERS

Unless indicated below, all photographs
are by Luciano Capelli.
P. Manzanilla & L. Capelli: pp. 48, 51, 52, 60,
68, 70, 92, 96, 98
Pepe Manzanilla: pp. 30, 31, 46,
50, 82, 87, 88, 91
Jorge Chinchilla: pp. 2, 29, 33, 34, 35, 95, 105
Gregory Basco: pp. 8, 39, 94
Diego Mejias: pp. 72, 100
Nick Hawkins: p. 63
Eduardo Carrillo: p. iv

COVER PHOTOS

Pepe Manzanilla,
Diego Mejias

LAYOUT DESIGN & PHOTO RETOUCHING

Francilena Carranza

LOGO, MAP & ILLUSTRATIONS

Elizabeth Argüello

ORIGINAL TEXT

Diego Arguedas Ortiz

ENGLISH ADAPTATION

Noelia Solano,
John Kelley McCuen

TEXT REVIEW

John Kelley McCuen,
Stephanie Monterrosa

CONCEPT

Luciano Capelli,
Stephanie Monterrosa,
John Kelley McCuen

PRODUCTION

Luciano Capelli,
John Kelley McCuen,
Stephanie Monterrosa

ABOUT
THE
PUBLISHERS

Cornell University Press fosters a culture of broad and sustained inquiry through the publication of scholarship that is engaged, influential, and of lasting significance. Works published under its imprints reflect a commitment to excellence through rigorous evaluation, skillful editing, thoughtful design, strategic marketing, and global outreach. The Comstock Publishing Associates imprint features a distinguished program in the life sciences (including trade and scholarly books in ornithology, botany, entomology, herpetology, environmental studies, and natural history).

Ojalá publishes illustrated books about the biodiversity and cultural identity of Costa Rica. With every title, we strive to intertwine images and text to transport readers on a voyage through this extraordinary country.

Zona Tropical Press publishes nature field guides and photography books about Costa Rica and other tropical countries. It also produces a range of other products about the natural world, including posters, books for kids, and souvenirs.

COSTA RICA ≈ REGIONAL GUIDES

GUANACASTE

MARÍA MONTERO AND LUCIANO CAPELLI

MONTEVERDE & ARENAL

MARÍA MONTERO AND LUCIANO CAPELLI

CARIBBEAN COAST

YAZMÍN ROSS AND LUCIANO CAPELLI

MANUEL ANTONIO BALLENA & CARARA

DIEGO ARGUEDAS AND LUCIANO CAPELLI

OSA & SOUTH PACIFIC

DIEGO ARGUEDAS AND LUCIANO CAPELLI

CENTRAL VALLEY

DIEGO ARGUEDAS AND LUCIANO CAPELLI

Principal font: Centrale Sans